Trees
in Black & White
A Visual Tour

Tony Howell

AMHERST MEDIA, INC. ■ BUFFALO, NY

Published by:
Amherst Media, Inc., P.O. Box 538, Buffalo, N.Y. 14213
www.AmherstMedia.com

Publisher: Craig Alesse
Senior Editor/Production Manager: Michelle Perkins
Editors: Barbara A. Lynch-Johnt, Beth Alesse
Acquisitions Editor: Harvey Goldstein
Associate Publisher: Katie Kiss
Editorial Assistance from: Ray Bakos, Carey A. Miller, Rebecca Rudell, Jen Sexton-Riley
Business Manager: Sarah Loder
Marketing Associate: Tonya Flickinger

ISBN-13: 978-1-68203-350-0
Library of Congress Control Number: 2017963172
Printed in The United States of America.
10 9 8 7 6 5 4 3 2 1

www.facebook.com/AmherstMediaInc
www.youtube.com/AmherstMedia
www.twitter.com/AmherstMedia

AUTHOR A BOOK WITH AMHERST MEDIA!

Are you an accomplished photographer with devoted fans? Consider authoring a book with us and share
your quality images and wisdom with your fans. It's a great way to build your business and brand through
a high-quality, full-color printed book sold worldwide. Our experienced team makes it easy and rewarding
for each book sold—no cost to you. E-mail submissions@amherstmedia.com today!

Contents

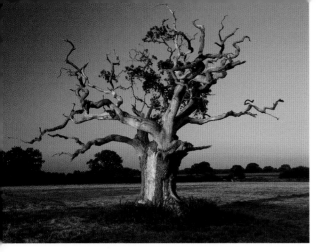

About the Author

Tony Howell is a professional photographer with over thirty-five years experience, based in Somerset, England. His images have been used in countless books, calendars, magazines, on television, in a Hollywood movie, on billboards, brochures, catalogues, greeting cards, posters, postcards, websites, national newspapers, fleets of vans, and much more. His clients include National Geographic, The BBC, Christie's, Royal Mail, The Tate, The National Trust, Penguin Books, Unicef, The Forestry Commission, and many more. His motto is "Peace and Joy through Beauty," and he tries to express this sentiment in his images. Trees are his favourite photographic subject.

www.tonyhowell.co.uk
www.facebook.com/TonyHowellPhotography/
www.twitter.com/tonyhfoto

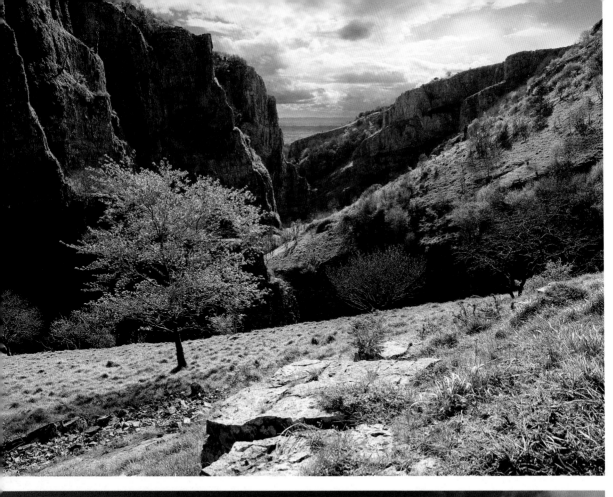
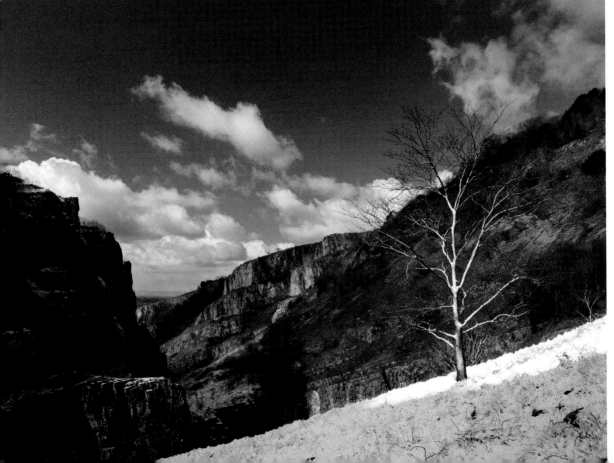

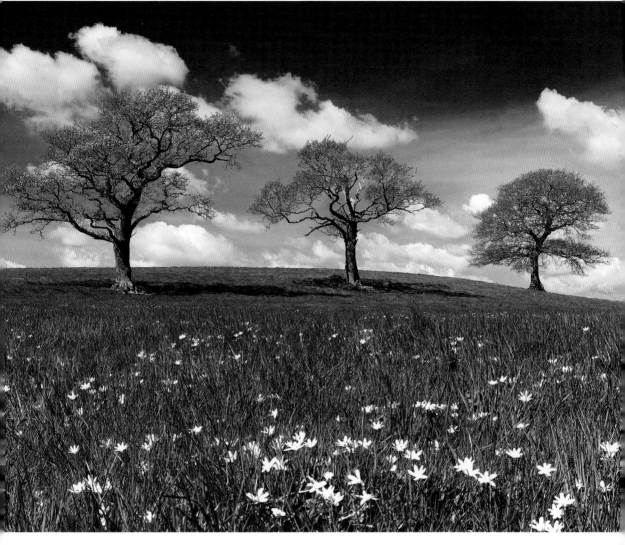

Oak Trees in Spring

above—These oak trees were photographed just as the first leaves were starting to appear. I've always liked groups of three, whether trees or plants. In the foreground are celandines (Ficaria verna), part of the buttercup family.

English Elm

facing page, top—English elm (Ulmus minor 'Atinia') is a deciduous tree native to southern and eastern Europe. Before metal was widely available, water pipes were made from the wood of the elm. The tree shown is in Cheddar Gorge, England, where cheddar cheese originates from. The local cheese is still stored to mature in the caves under the limestone cliffs, where the temperature is constant.

facing page, bottom—The same tree in winter.

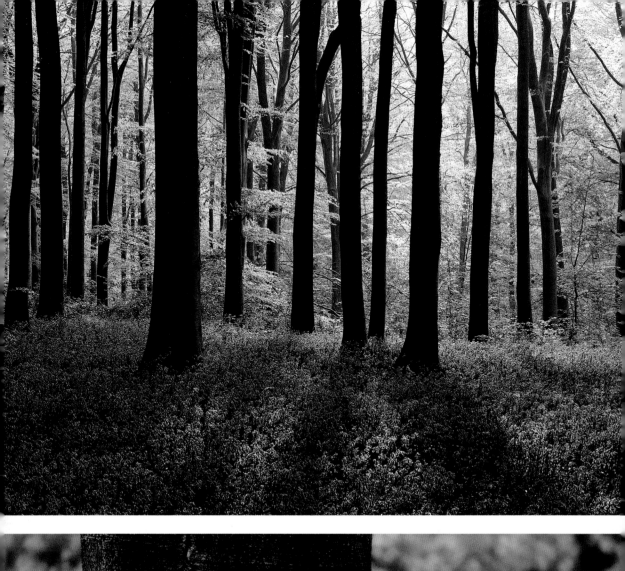
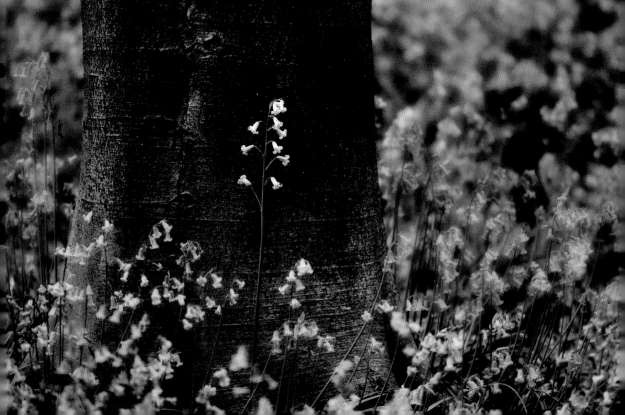

Beech Trees and Bluebells

facing page, top—This woodland scene, featuring beech trees (Fagus sylvatica) with dense bluebells flowering beneath, is typical of the month of May in England. The scent of the bluebells (Hyacinthoides) can be subtle or sometimes quite strong. They often grow among beech trees, as the conditions under them are perfect. New leaves don't form on the beech trees until the bluebell flowers are almost finished, giving the flowers plenty of light early in the year. In autumn, the fallen beech leaves and dying-off bluebell leaves give valuable nutrients back to the soil, benefitting both.

facing page, bottom—A closer view of bluebells growing under a beech tree.

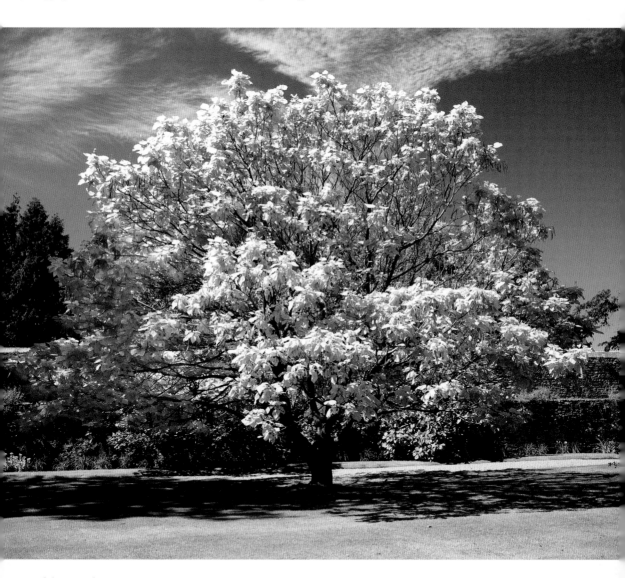

Golden Indian Bean Tree

above—This golden Indian bean tree (Catalpa bignonioides 'Aurea') was photographed in Wells, Somerset, England. It's a stunning tree with very large, bright leaves and showy, bell-shaped flowers in late summer.

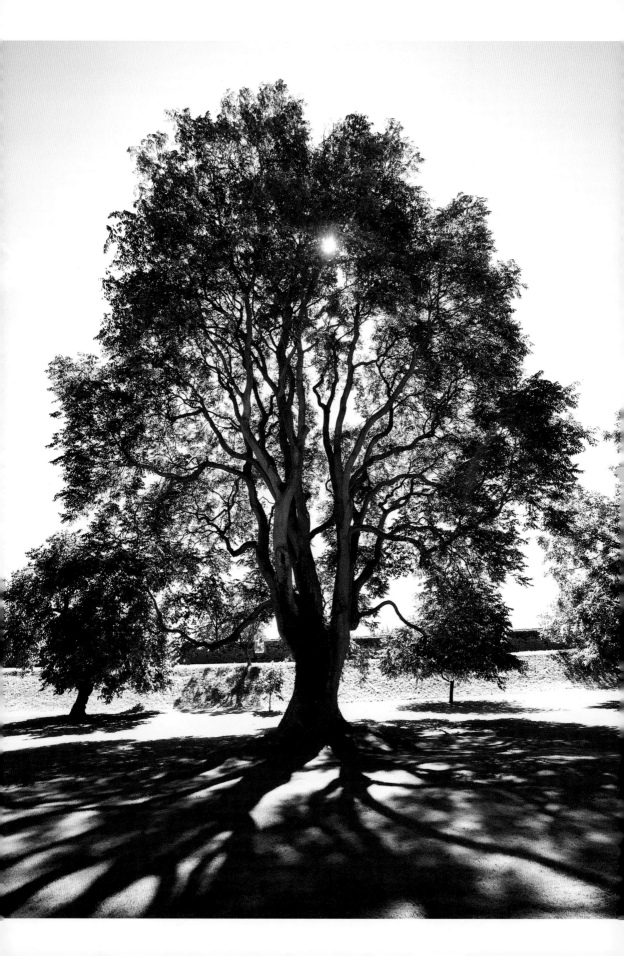

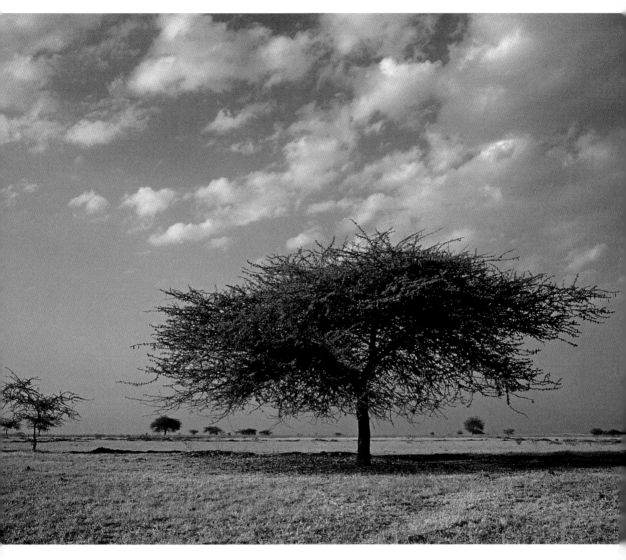

Thorny Acacia

above—This is a thorny acacia (Acacia catechu) south of Mumbai, India—although it could easily be on the African continent, which looks similar in many places. Acacias provide food for both animals (usually their fallen pods) and humans. You may have noticed acacia as an ingredient in soft drinks, mints, and even chewing gum.

Tree of Heaven

facing page—Tree of heaven (Ailanthus altissima) is named because of its tendency to grow fast and straight upwards—but there are now calls for what some have renamed the "tree of hell" to be strictly controlled because of the threat it poses to native plants. The tree sends out a poison to stop other species growing nearby and sends out a mass of suckers that smother other plants. This particular 128-year-old tree (planted in 1885) recently blew down in a gale. It was located in Wells, Somerset, England.

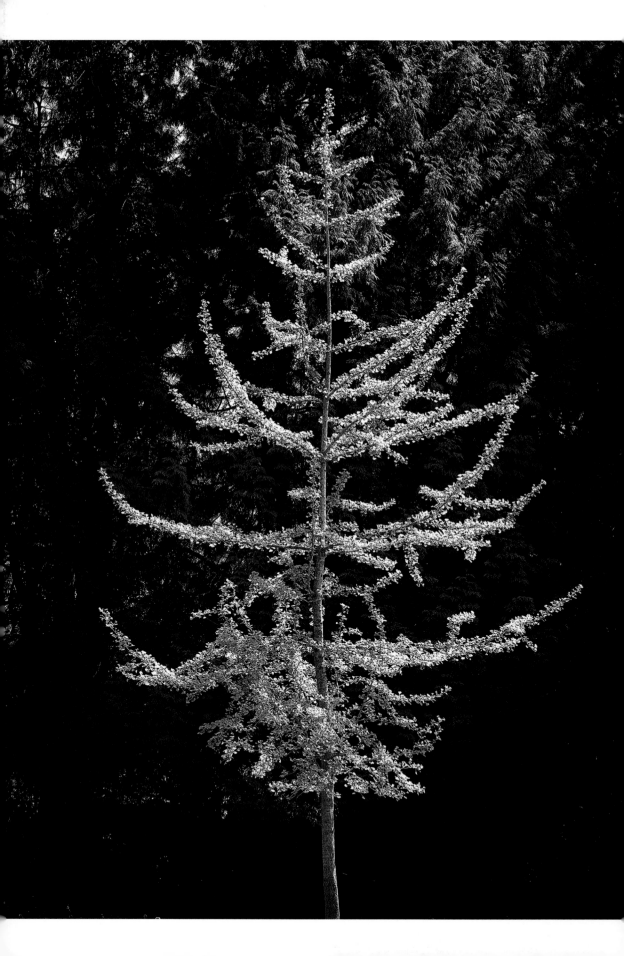

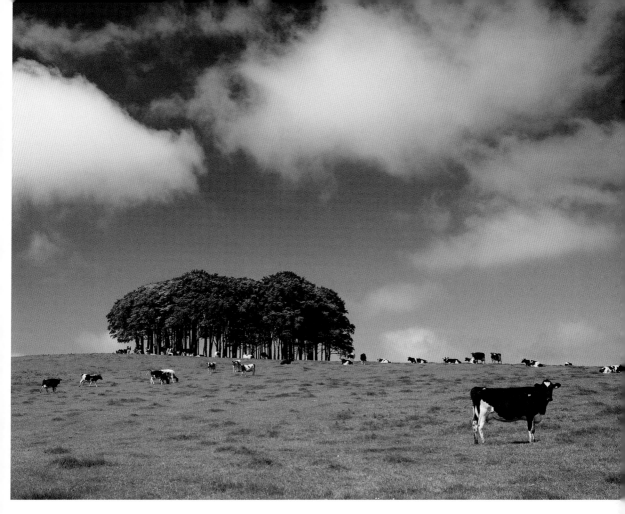

Beech Copse

above—This copse of beech trees (Fagus sylvatica) on a hilltop in Southern Great Britain is a local landmark, visible for miles around. It's also a useful place for cows to avoid the weather. Seeing it always makes me feel good—as it's usually when I'm going south for my holidays!

Ginkgo Biloba

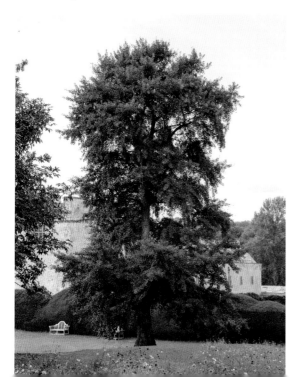

left and facing page—The maidenhair tree (Ginkgo Biloba) is an ancient tree from Asia, found in fossils over 300 million years old. Botanically remote from all other trees and plants, it is a survivor from a group called Ginkgoales and is now the only living representative. One tree in China is thought to be 3000 years old. The image on the facing page shows a young specimen, around 5 to 10 years old. To the left is a mature ginkgo biloba tree.

Joshua Tree

below—The Joshua tree (Yucca brevifolia) is native to the Southwestern United States. This one was photographed on a journey between California and Nevada. The tree was named "Joshua" because of the Biblical story of Joshua's hands reaching up to the sky in prayer. *The Joshua Tree* is also a famous (and very good) album by the Irish rock band U2, released in 1987.

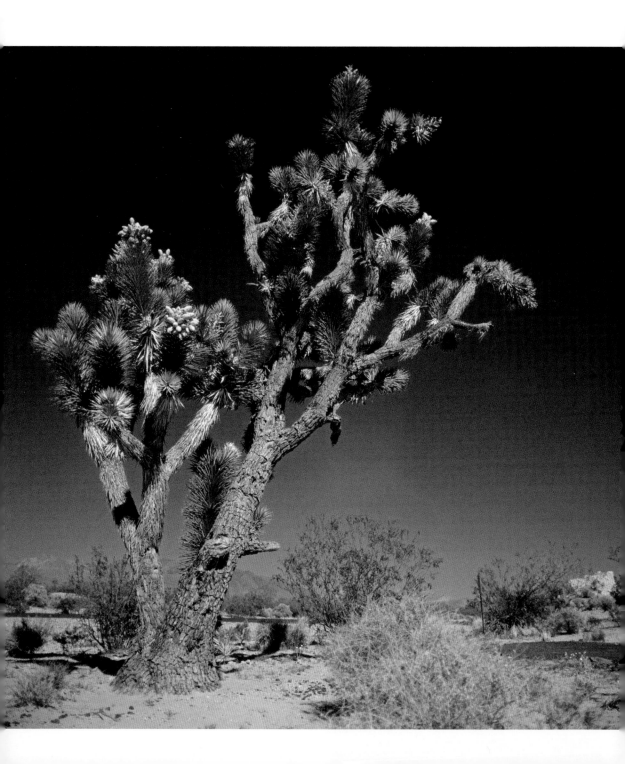

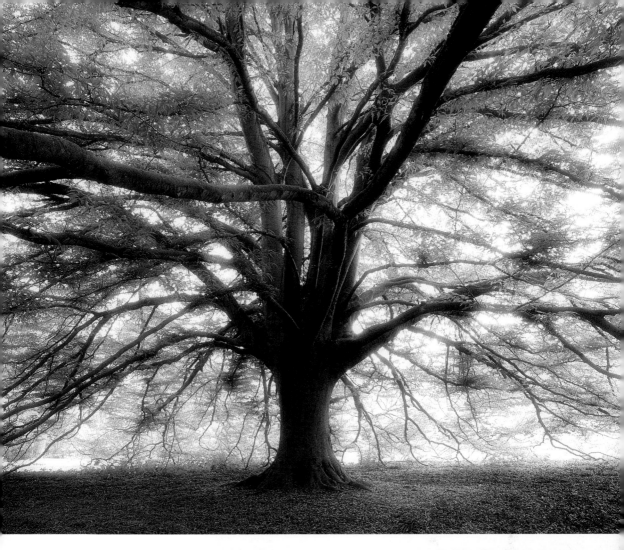

Fern-Leaved Beech

above—The fern-leaved beech tree (Fagus sylvatica 'Asplenifolia') has fabulous spreading branches that hang low and even touch the ground. From the outside, it is dome shaped, making the den-like inside a favourite place for children.

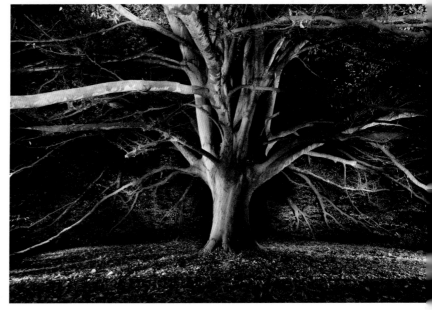

right—This is the same tree, photographed at night. It was illuminated with my flashlight during a long exposure.

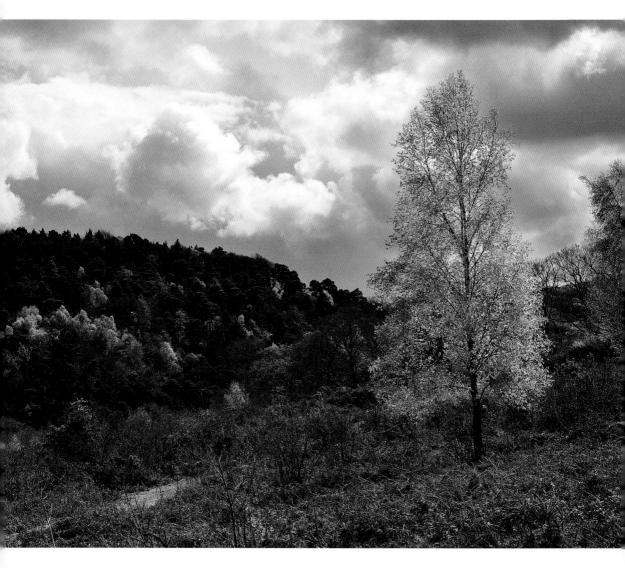

Silver Birch

above—The silver birch (Betula pendula) can be used to improve soil quality for other plants to grow. Its deep roots bring otherwise inaccessible nutrients into the tree, which are recycled into the soil when it sheds its leaves in the fall.

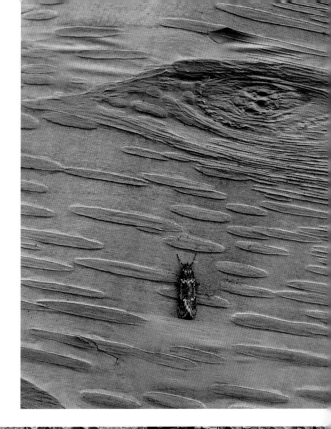

Birch Trees in Snow

below—These birch trees in snow were photographed in Bath, England. The birch is a thin-leaved deciduous hardwood tree of the genus Betula. Birches produce an abundance of sap in spring and a cut stump will "bleed" for weeks.

Birch Tree with Moth

right—A moth on the beautifully textured bark of a birch tree at Westonbirt Arboretum in England.

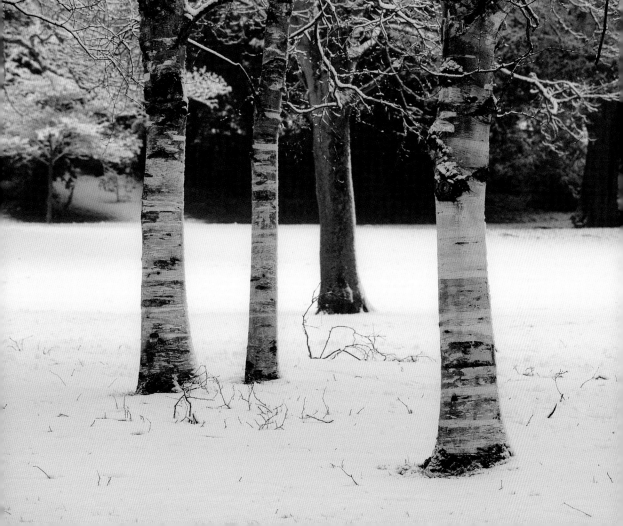

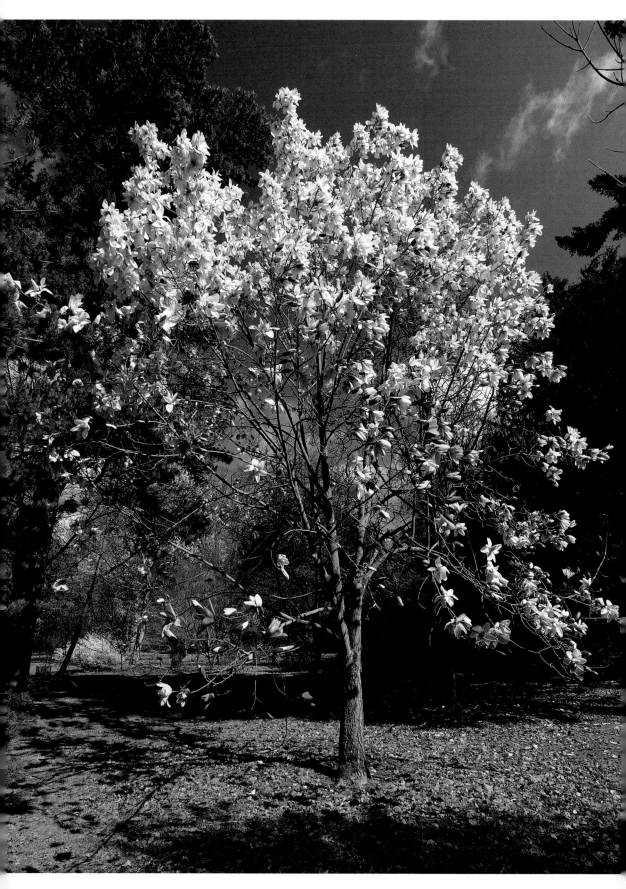

Magnolia

facing page—Magnolia dawsoniana is a small tree noted for its large flowers, a spectacular sight in the spring. It can grow up to 20m and is native to the provinces of China.

right—Inside a magnolia flower.

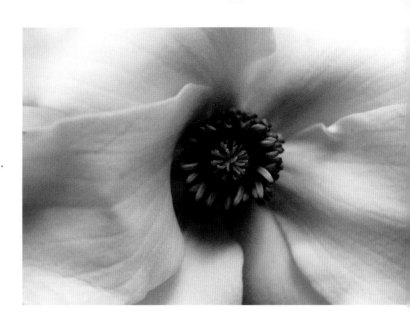

below—Magnolia dawsoniana flowers range from soft pinky white to deep pink. As the flowers are so ancient (appearing before bees), they have evolved to be pollinated by beetles.

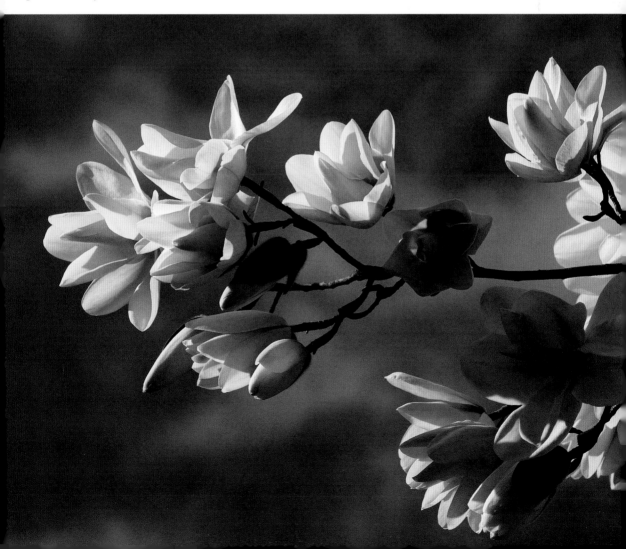

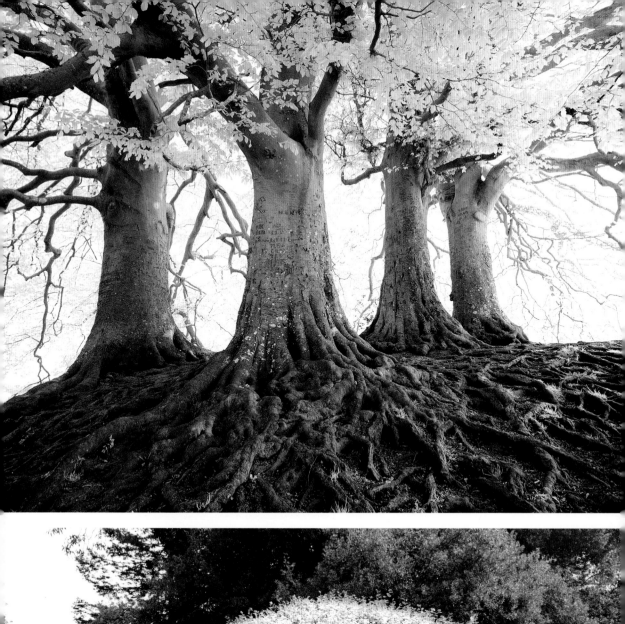
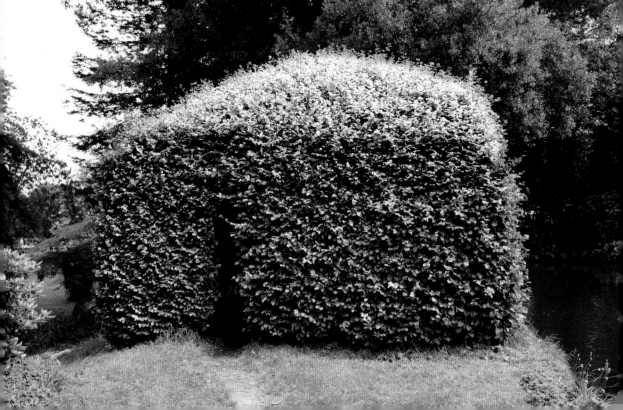

Beech Trees in Infrared

facing page, top—I photographed these beech trees at Avebury Ancient Monument in Great Britain using a digital infrared camera (which makes green foliage appear white). Because of the narrow slope they are growing on, the roots have crowded out the area, forcing them to harden above ground.

Beech House

facing page, bottom—Common beech (Fagus sylvatica) is often used for hedging as it keeps its attractive leaves until late in the season. It's also used to make large features like this fabulous Beech House at Forde Abbey, England.

Dense Woodland in Autumn

below—Here, we see various trees photographed in autumn. There's something special about walking through dense woodland; the regular, straight lines are very relaxing during the day. At night it's a spookier place altogether, but I still love to go there with a good flashlight and (hopefully!) no-one else around.

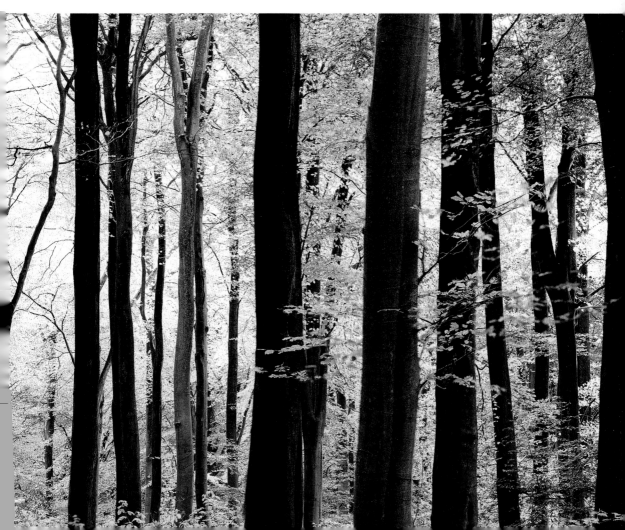

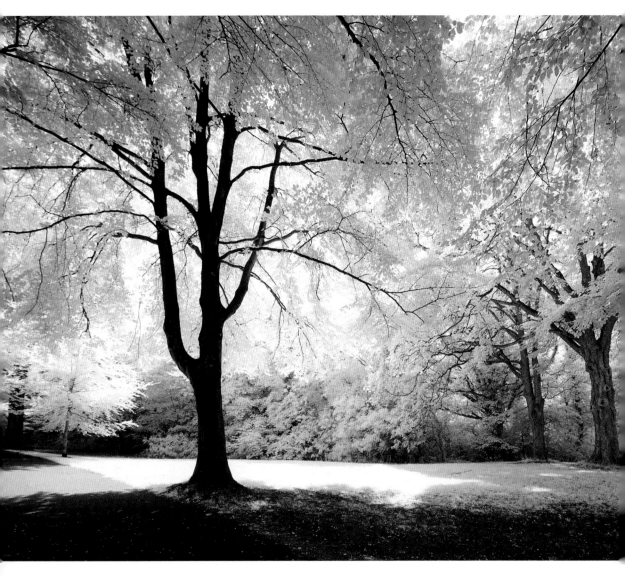

Infrared Photography

above—These beech trees (Fagus sylvatica) in England were captured using an infrared camera. This style of photography works well in black & white, because the infrared light records the foliage as white. This enhances the contrast between the leaves and the dark trunks and branches.

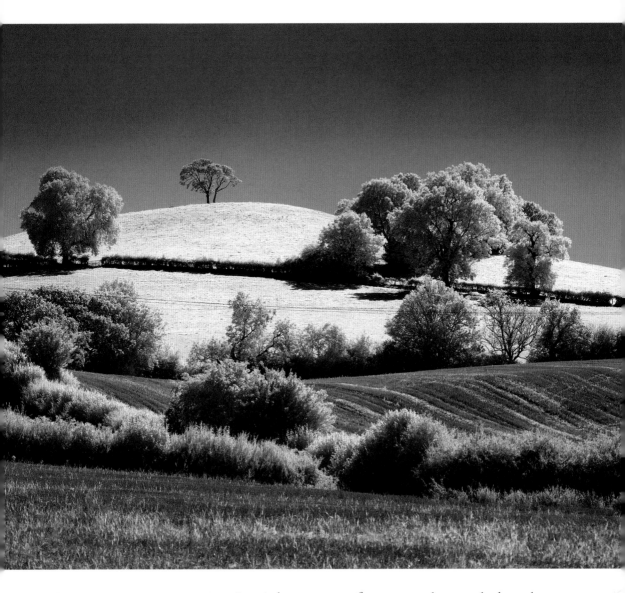

above—A varied assortment of trees were photographed on a hot summer day. I captured this image in infrared to create an ethereal effect. Infrared is a type of electromagnetic radiation, what we largely think of as "light," but with longer wavelengths that fall into the invisible spectrum—just beyond the ability of human vision to perceive.

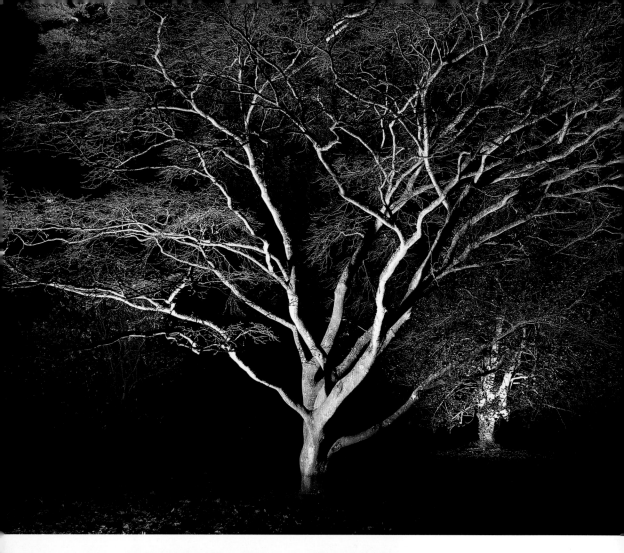

Light Shows

above—Some arboretums have winter light shows that are well worth a visit. Without leaves, trees like this maple (Acer palmatum) show all their delicate beauty, with their tiny, intricate branches picking up the light.

Twisted

left—Here's another Acer palmatum in winter. This twisted specimen was photographed in daylight.

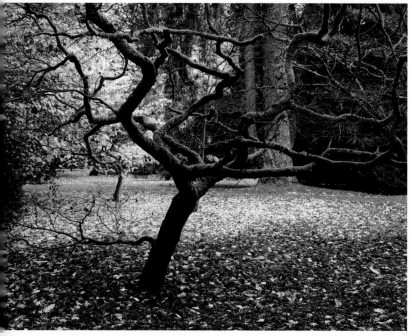

Illuminated Cedar

below—This cedar of Lebanon (Cedrus libani) was photographed at dusk in Westonbirt Arboretum, England. I was so delighted when they decided to illuminate a lot of their trees in winter. Dusk comes at around 4PM in November in England, so I can photograph day and night images and still get home in time for a good hot dinner!

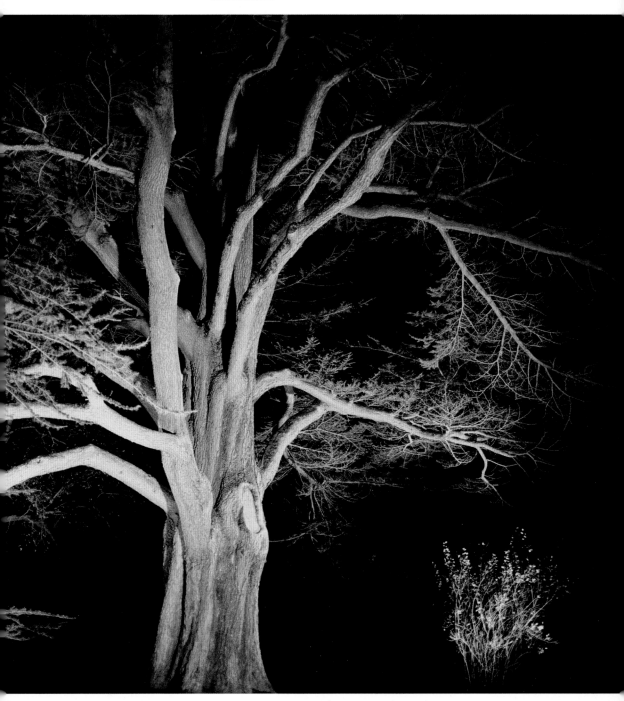

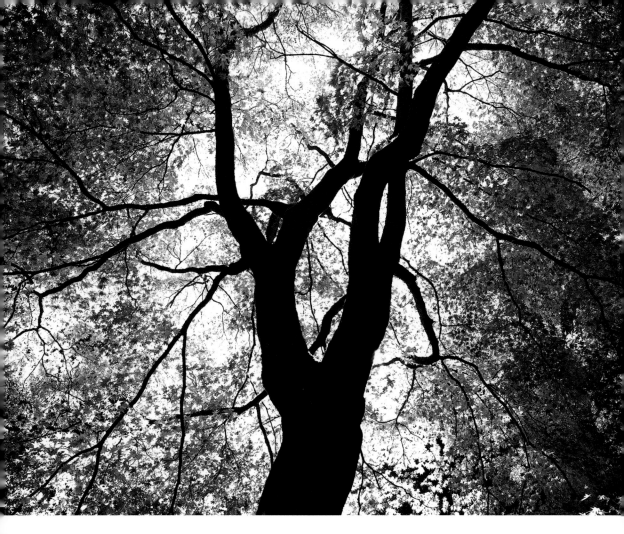

Looking Up

above—This image of a Japanese maple (Acer palmatum) shows one of my favourite ways of photographing trees. Pointing the camera upwards, against the light, with a wide-angle lens increases the contrast and makes for a more dramatic image—especially in black & white. I spent a few hours here making images while many people walked by without anyone looking upwards!

Beech Trees: Night and Day

facing page, top—I photographed this beech tree (Fagus sylvatica) on top of a hill at night. I set my camera for a long exposure (131 seconds), giving me enough time to walk around the tree and illuminate it with my flashlight. I like being out photographing at night; it has a special atmosphere and gives me a good sense of solitude, which allows me to concentrate fully on my images.

facing page, bottom—This is the same group of beech trees, but this time photographed during the day.

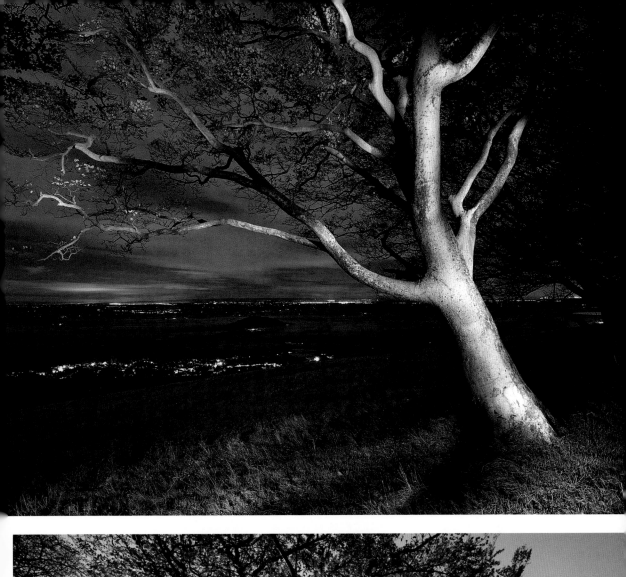
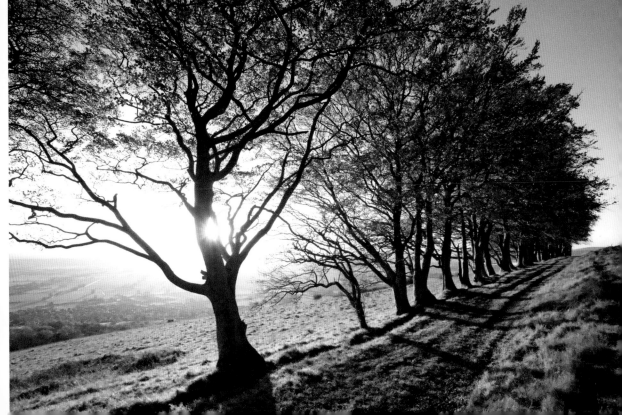

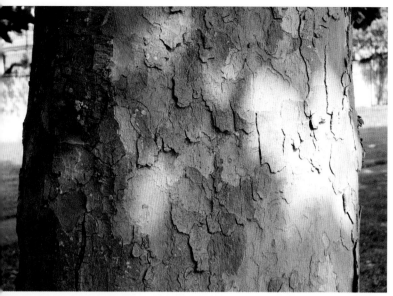

London Plane Trees

below—I photographed these London plane trees (Platanus × acerifolia) in Bath, England. London planes are planted for their ability to adapt to urban conditions and their resistance to pollution. They have superb, fairly distinctive markings on their bark.

left—The shaggy, peeling bark that is typical of the London plane tree.

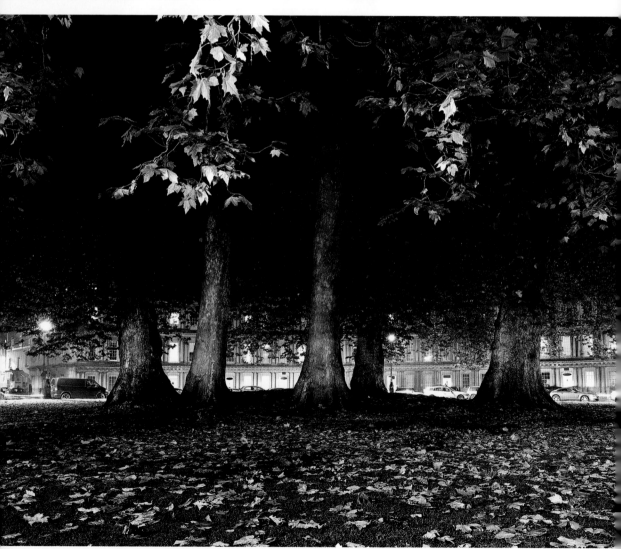

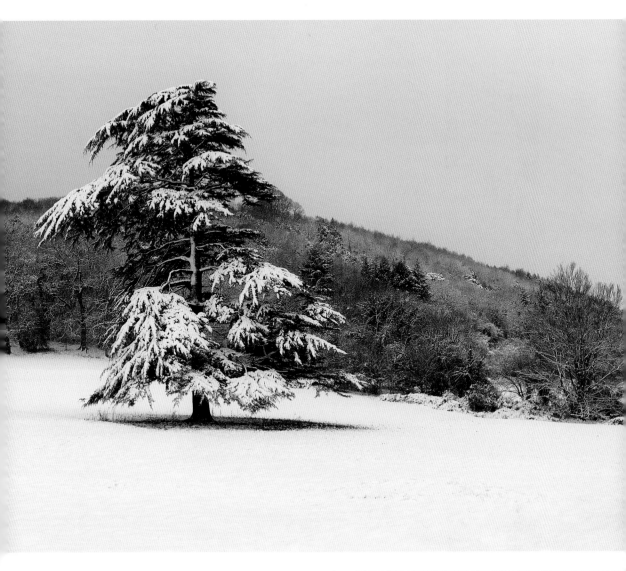

Pine Trees in Winter

above—Most regions of the
Northern Hemisphere
have some native species of
pine, which were mostly
called "firs" until the 19th
century. Pines mostly have
the male and female cones
on the same tree.

right—The same pine tree
during a foggy morning in
March.

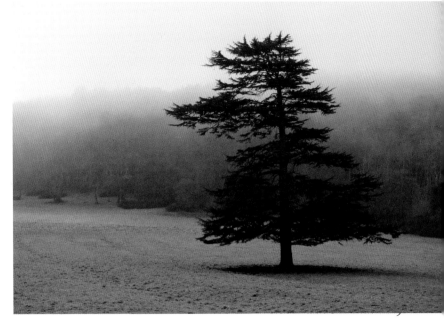

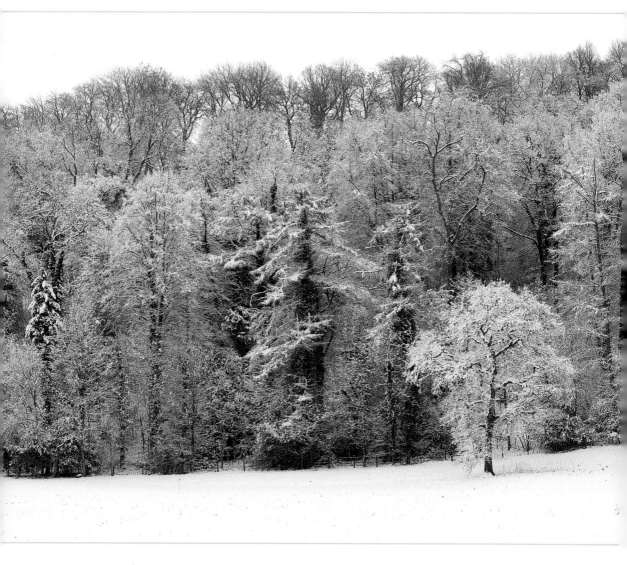

A Dusting of Snow

above—A dusting of snow has landed on the many tiny branches in
this stand of mixed trees. This highlights the delicate appearance
of the trees, most of which are without leaves. The smaller tree
planted in front gives the eye a focal point to rest on.

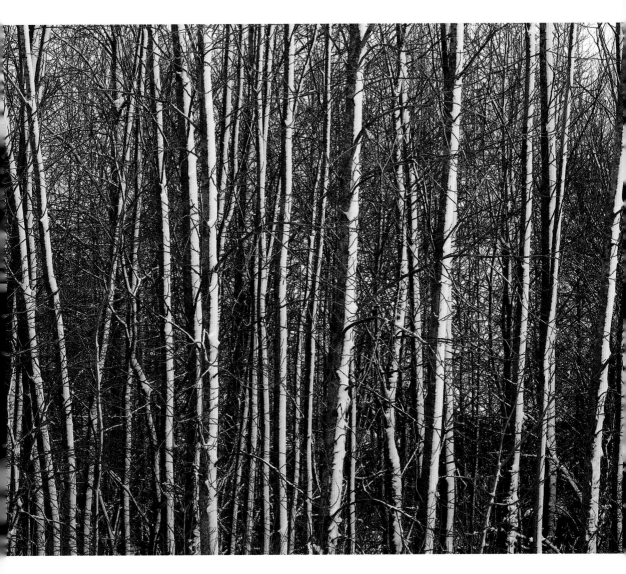

Blowing Snow

above—Snow blowing in one direction coated one side of these closely planted trees, making them a really good black & white subject.

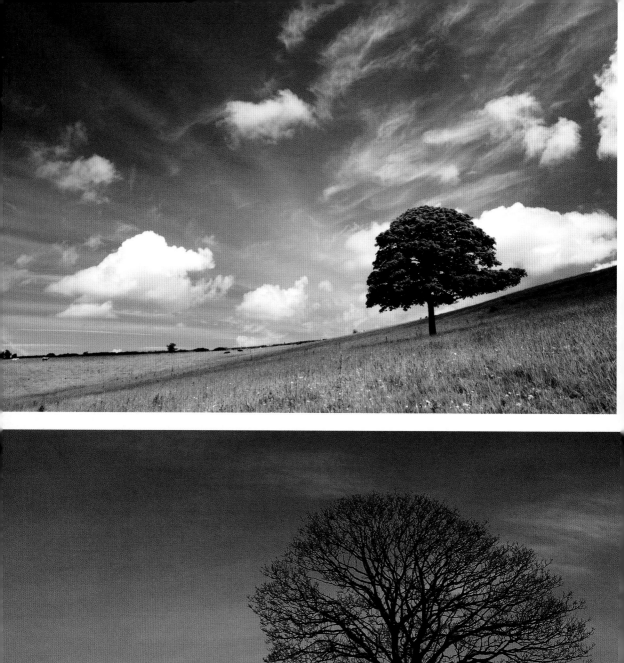
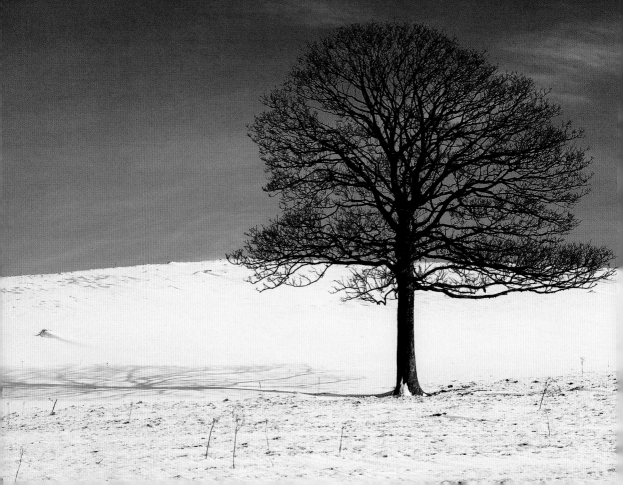

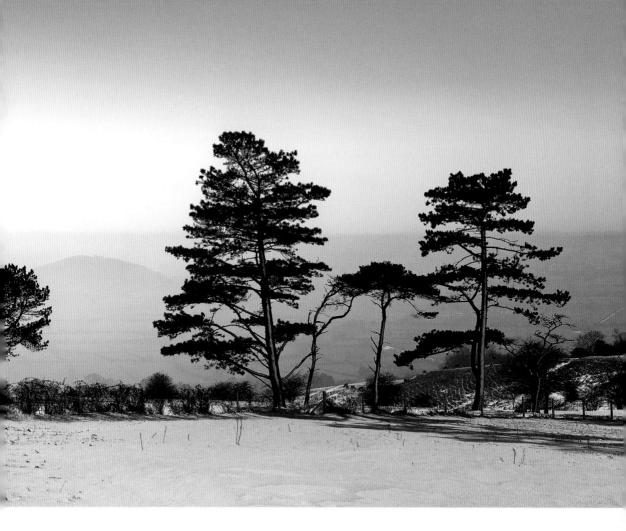

A Solitary Tree

facing page, top and bottom—The sycamore maple tree (Acer pseudoplatanus) is, as the Latin name "pseudoplatanus" suggests, a tree like a plane tree. It's a welcome sight to get a solitary tree planted on a hill; they make one of the best photographic subjects. This one is near my home in Somerset, England, and I've captured it at all times of the year. It is a favourite haunt of mine.

Shapely Pines

above and right—As you can see, the planted location of these pine trees nicely highlights their shape. Standing on the brow of a hill, overlooking a distant view, they really stand out from both directions. This is a place I frequent when

I feel like a good solitary walk with my camera, I love it here!

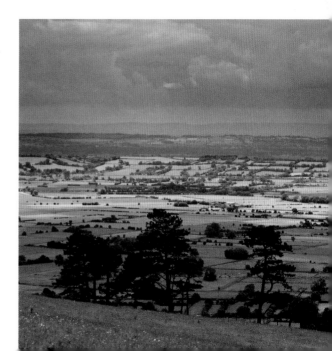

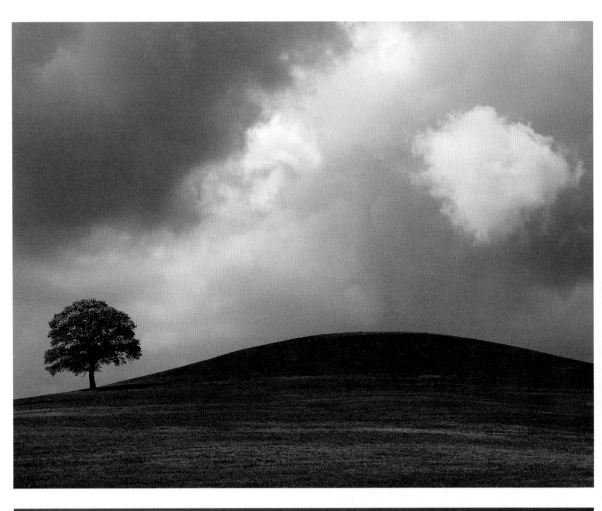

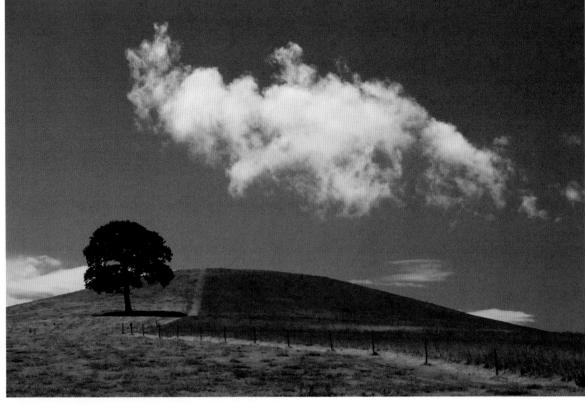

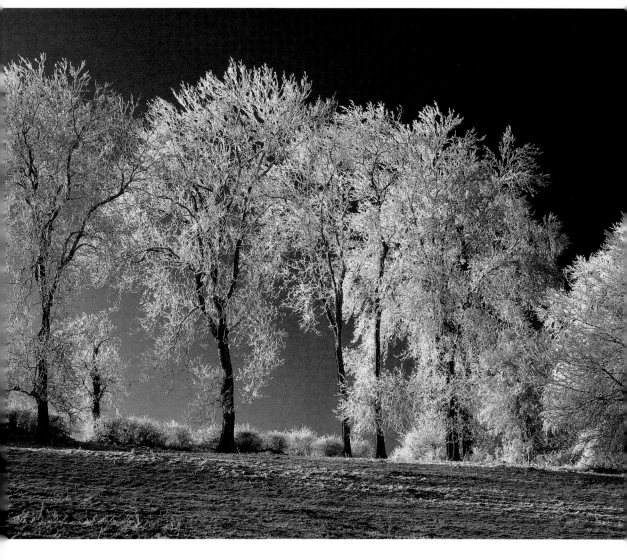

A Clear Sky

above—These trees looked so dramatic, covered in snow and lit from the side by the low winter sun. Luckily, there were no clouds at this moment, which would have detracted from the simplicity of the image. The clear, dark sky allows the bright tones of the trees to stand out better.

Some Drama in the Sky

facing page, top—The small cloud passing this oak tree completed the image perfectly, balancing the composition from left to right. Some drama in the sky often benefits monochrome images.

facing page, bottom—This is the same tree on a different day.

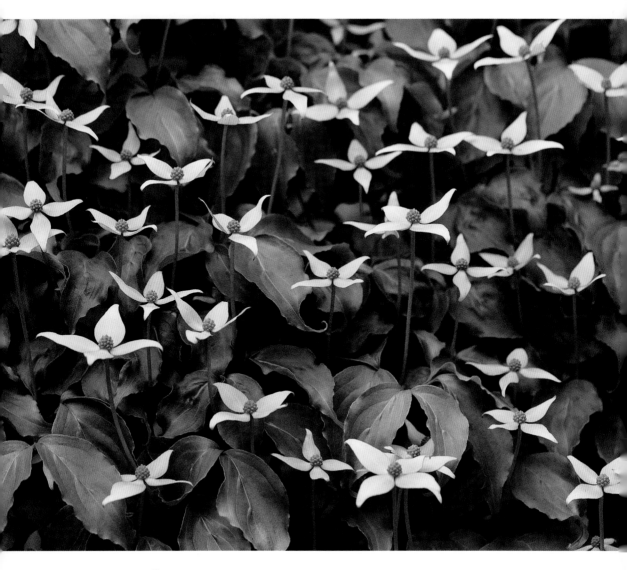

Korean Dogwood

above—The flowers of the Korean dogwood (Cornus kousa) are one of the most distinctive tree flowers. The small tree is native to Korea, China, and Japan, and grows to around 7m tall.

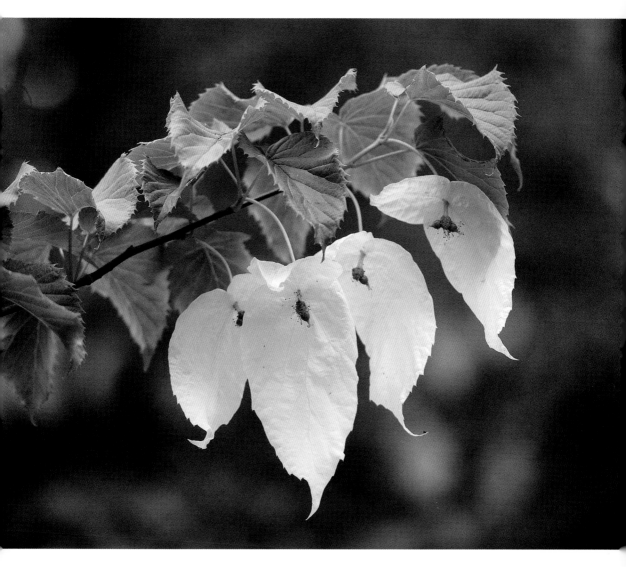

Handkerchief Tree

above—Handerchief tree (Davidia involucrata) is another tree grown mainly for its flowers. It's also known as the ghost tree and dove tree. The actual flowers are very small, held within a pair of large white bracts that look like handkerchiefs.

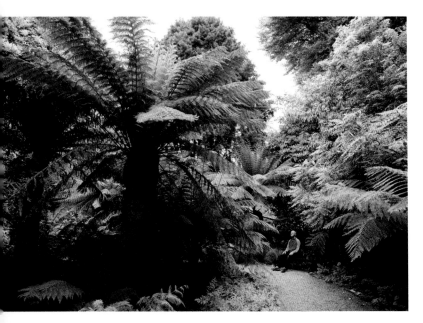

Tree Ferns

below—These tree ferns (Dicksonia Antarctica), were photographed in Cornwall, England. Some species of tree ferns can grow up to 20m tall in their native countries. They are found growing in tropical and subtropical areas, as well as rainforests. England is a little too cold for them, but they do quite well in the South.

left—Here I am, sitting amongst the tree ferns and having a rest from photographing—just looking for once!

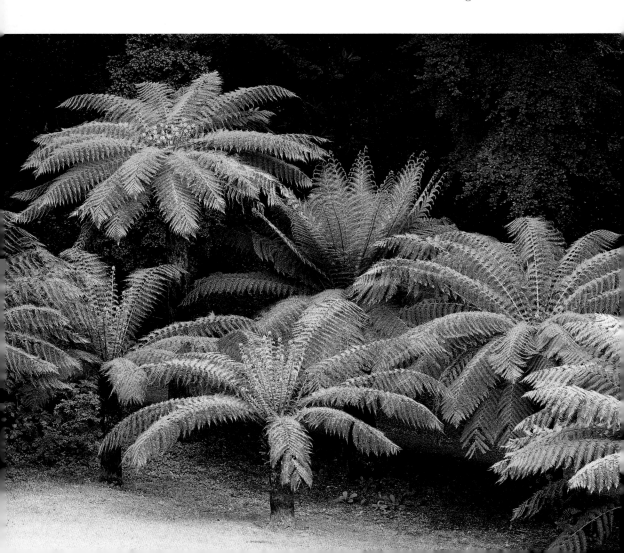

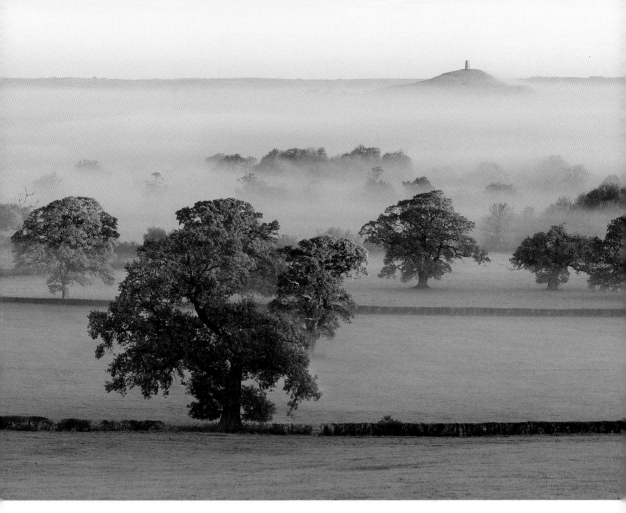

The Stuff of Legends

above—These oak trees (Quercus robur) at Glastonbury, England are reaching above the low-level Autumn mist. The oaks stand proud—as does Glastonbury Tor, a local landmark associated with King Arthur. There are many trees around the world associated with legends. Given the age of some trees, it's not surprising!

right—This image from the same location was photographed during the summer.

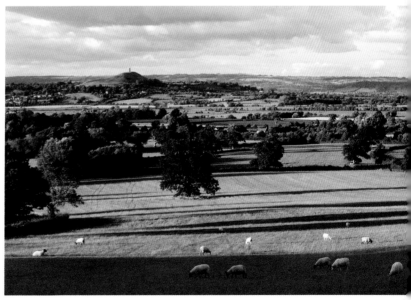

A Dramatic Composition

below—Pointing a wide-angle lens up to the tops of these beech trees makes for a dramatic composition. This image works well because the sky was mostly clear of clouds; more clouds would have confused and cluttered the image. I like simplicity, and prefer to take things out of my compositions (by zooming in or altering the camera position) rather than adding them.

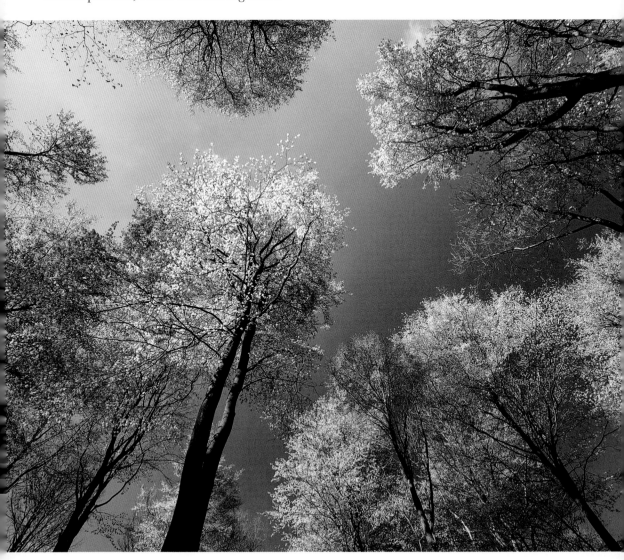

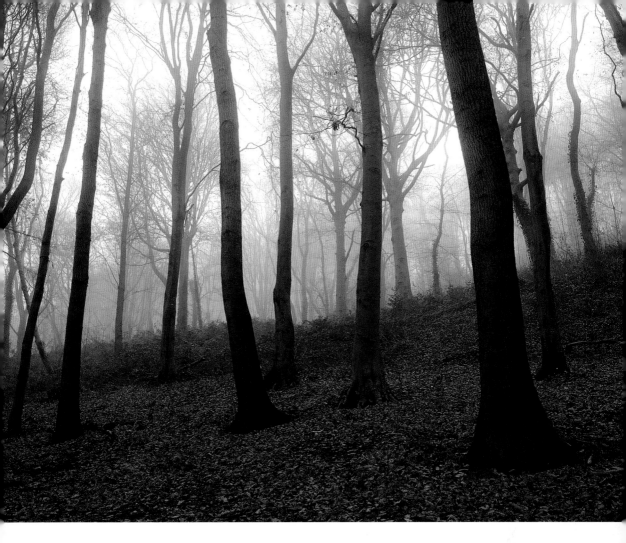

Mist in the Forest

above—Mist really adds atmosphere to woods and forests, softening the look and highlighting the shapes. Some call it spooky, but I find it simply beautiful. I live really close to these trees and see them often— they've never looked this good since.

right—Another image of beech and oak trees, from the same photo shoot in Weston Woods, England.

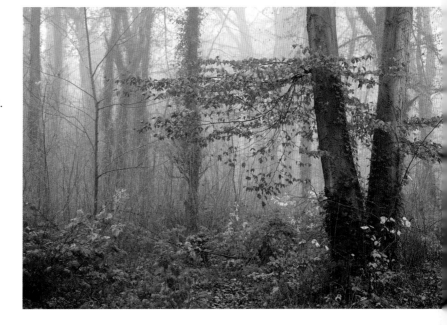

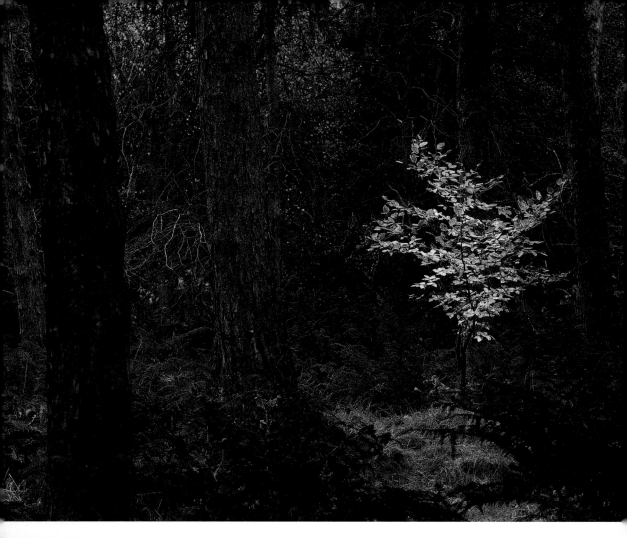

Young Beech

above—In a dark pine wood, I found this lone beech tree (Fagus sylvatica), a sapling that was struggling to find enough light to help it become an adult tree amongst its giant pine neighbours.

left—A closer view of a young beech tree in autumn.

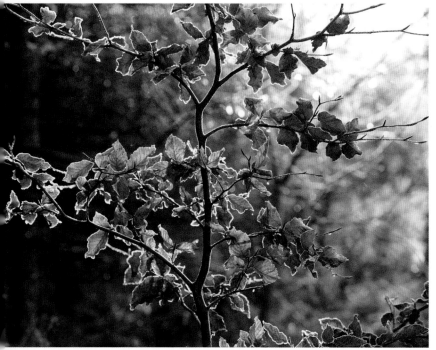

Straight and Narrow

below—Here is a slightly older beech tree (Fagus sylvatica). It was unable to produce its normal wide branches because of the lack of light caused by the older (mainly pine) trees nearby. As a result, this specimen had to grow up straight and narrow.

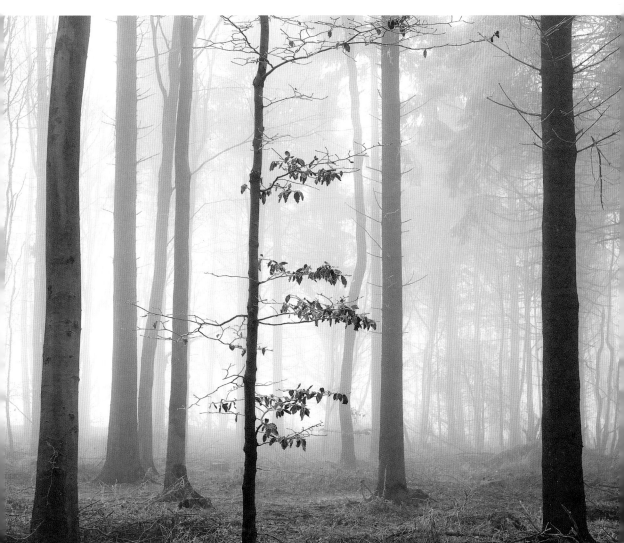

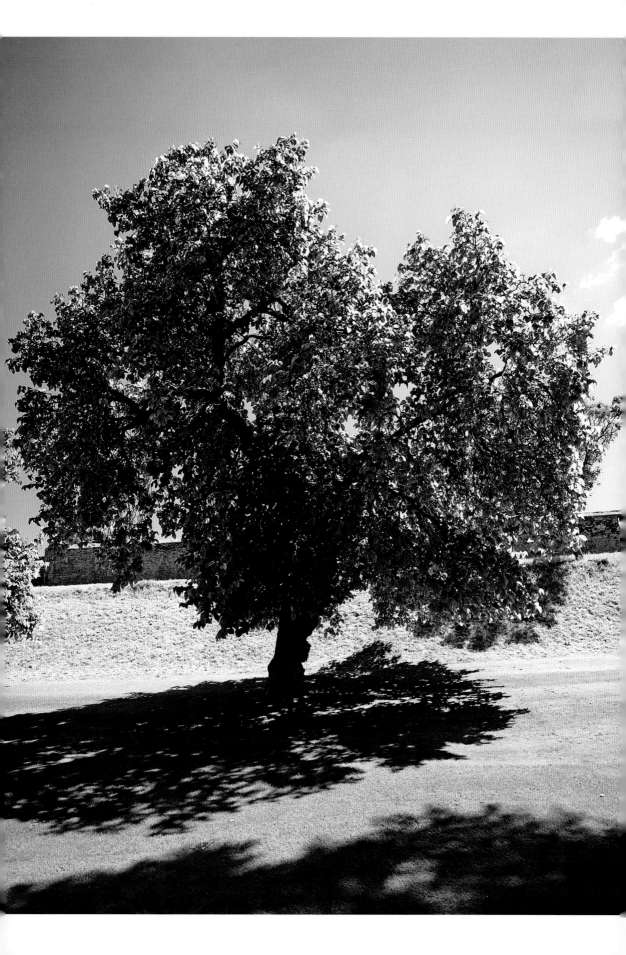

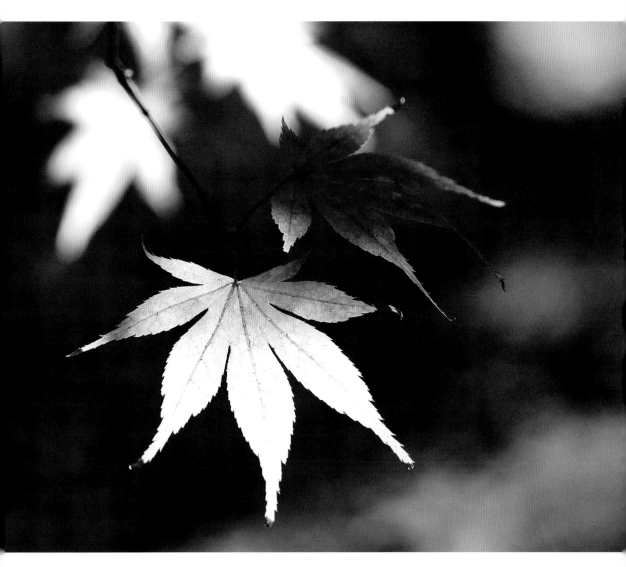

Japanese Maple

above—The distinctively shaped leaves of the Japanese maple (Acer palmatum) are a familiar sight to anyone who loves trees. The range of colours delights gardeners and tree lovers whether in spring, summer, or autumn—which is the most popular time to see them as they change colour.

Black Mulberry Tree

facing page—Black mulberry tree (Morus nigra) is grown mainly for its deliciously sweet and tart fruit. These are rarely found for sale in shops, because the fruit is so difficult to cultivate and pick. You have to wear gloves if you want to avoid the fruit staining your hands, but the fruit is worth it! I like them so much we bought a mulberry tree for our garden. After four years it produced fruit, but now it's getting so big I've had to prune it!

Chinese Red Birch

below—Chinese red birch (Betula albosinensis) has wonderful distinctive bark; it is textured and finely marked, with horizontal lines that stop and start abruptly like dashes. Friends think I'm bonkers photographing tree bark, but now they're in a book—so I have the last laugh!

facing page—This is a slightly different specimen of Chinese red birch, with bark that has peeled to give it a particularly shaggy look—more like the paperbark maple tree.

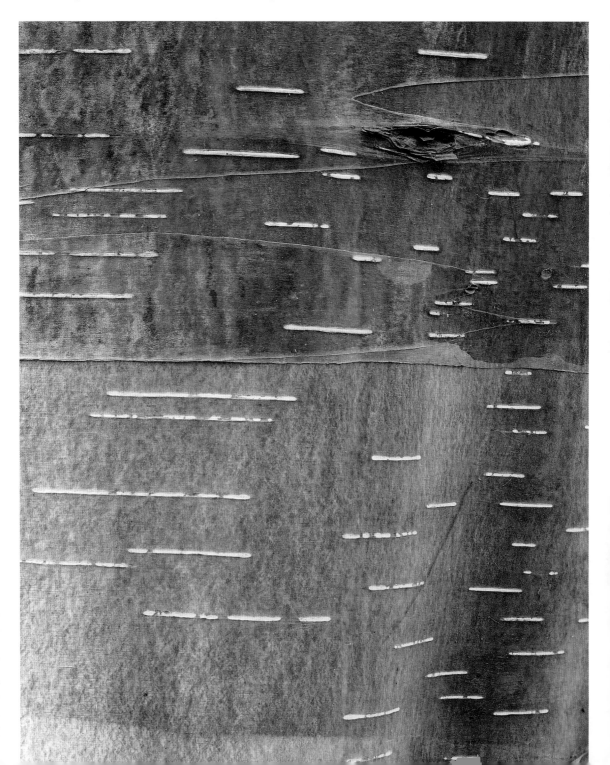

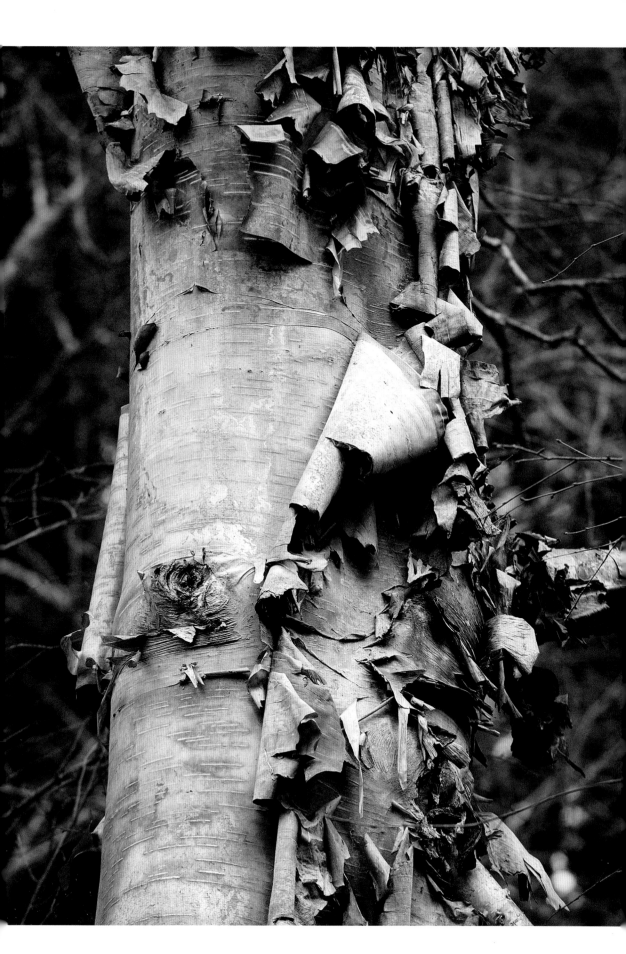

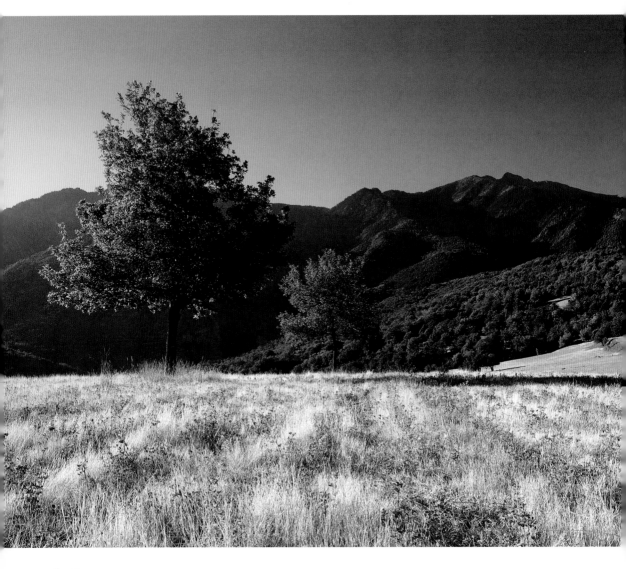

The Pyrenees

above—These trees were photographed at sunrise near Mount Canigou, in the Pyrenees of France. The Pyrenees are a large range of mountains, mostly covered with trees. This makes them a cooling place to visit in the hot summers that Southern France receives. I had real trouble sleeping on this trip because of the heat.

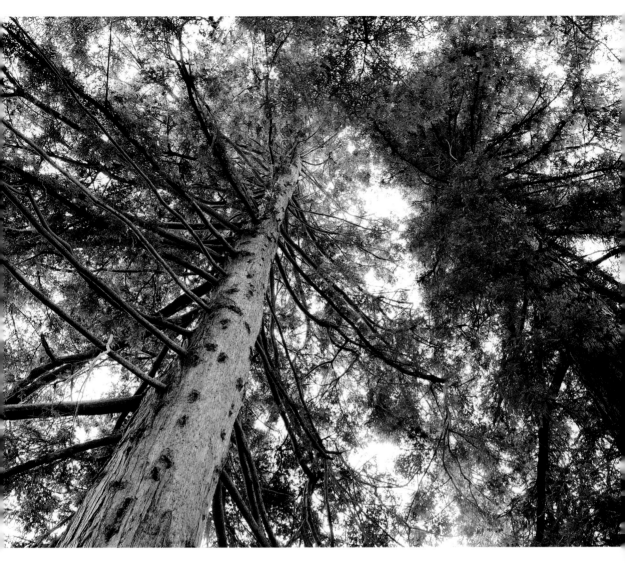

Coast Redwoods

above—I photographed these coast redwood trees (Sequoia semper-
virens) at the Westonbirt Arboretum in Gloucestershire, England.
Sequoia sempervirens are the tallest living trees on Earth, reaching
up to 115m in height in their native California—making them even
taller than the giant sequoia. The climate there is ideal for them;
it's mild all year with high rainfall. London's Big Ben is only 96m
high, so they would tower way over it!

Ash Trees in Infrared

below—Shot with a digital infrared camera, these ash trees (Fraxinus) planted on the edge of a lake in Somerset, England, look stunning with the light pouring through the leaves. Infrared can make a fairly normal image come alive as it emphasizes different tones than regular cameras.

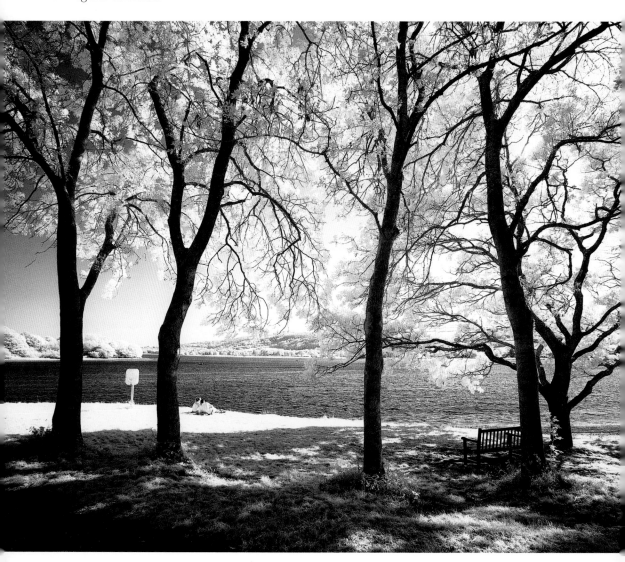

Oaks in Infrared

below—These oak trees (Quercus) were planted in a hayfield on the Somerset Levels in England. Using an infrared camera makes a blue sky look very dark and dramatic in black & white. This provides nice contrast with the bright white clouds. This was one of the hottest days of the summer (hot for England, that is!).

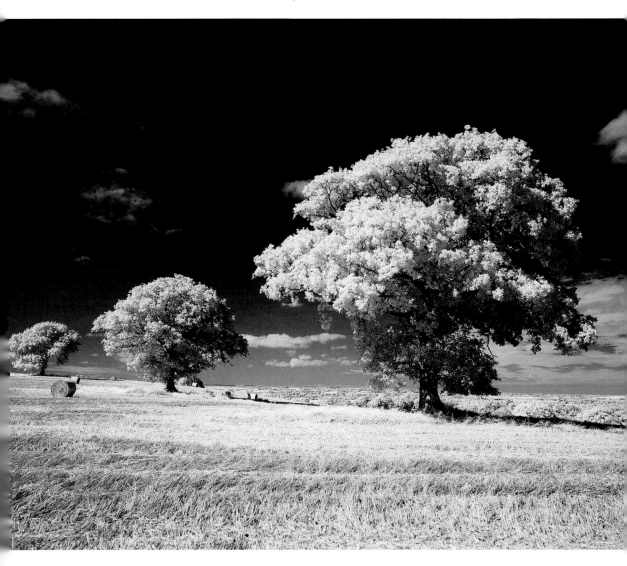

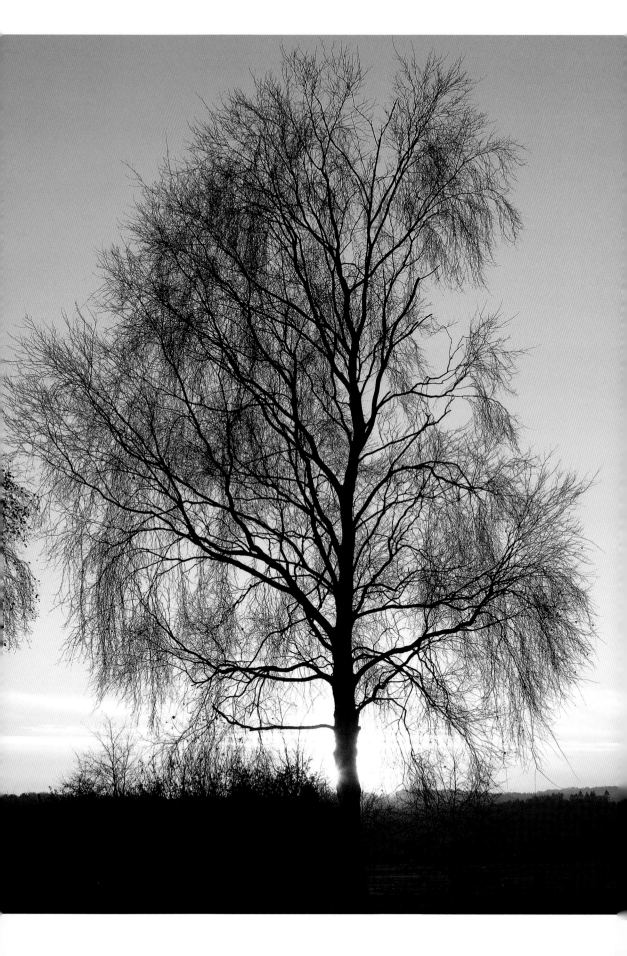

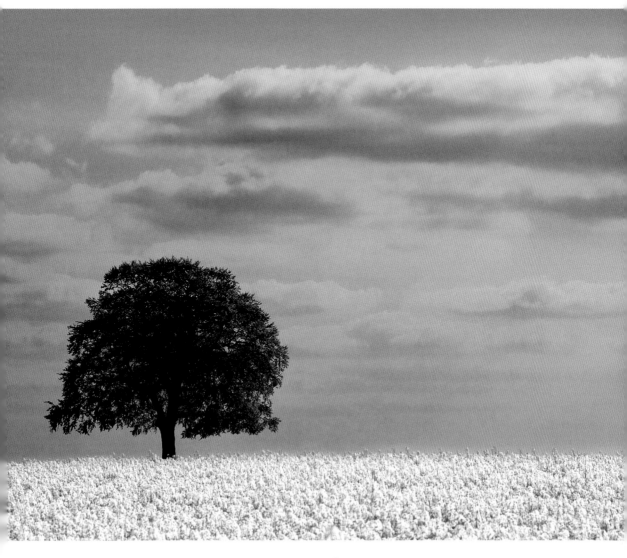

Solitary Trees

above—Standing alone in a field of rapeseed (Brassica napus), this beech tree (Fagus sylvatica) looked great. Its leaves contrasted nicely with the bright flowers of the oilseed rape. Add an interesting sky and you have a peaceful, evocative picture.

Silver Birch Tree

facing page—The tiny, delicate branches of a silver birch tree (Betula pendula) really show up in winter. Here, they were photographed against the setting sun on a late afternoon in November. Personally, I think some trees look just as good in winter as they do in any other season.

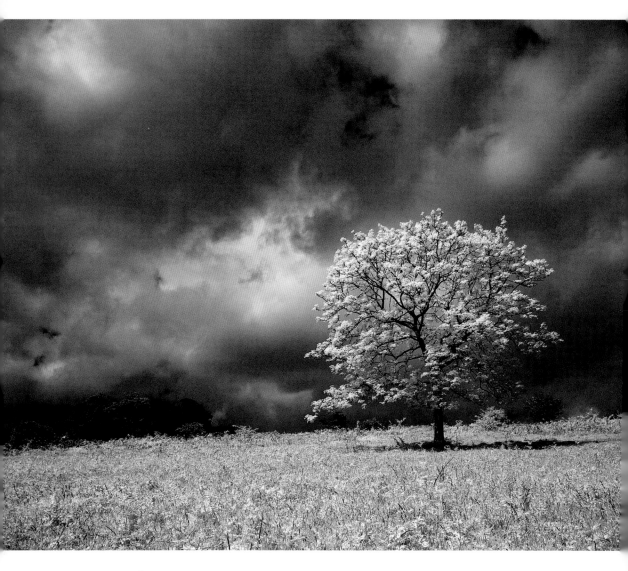

A Happy Find

above—I photographed this ash tree (Fraxinus) in the summer, with a dramatic sky behind it. Using an infrared digital camera has made the foliage of the grass and leaves turn a bright white. On this day, I was simply walking with my family—but, luckily, I was carrying a camera.

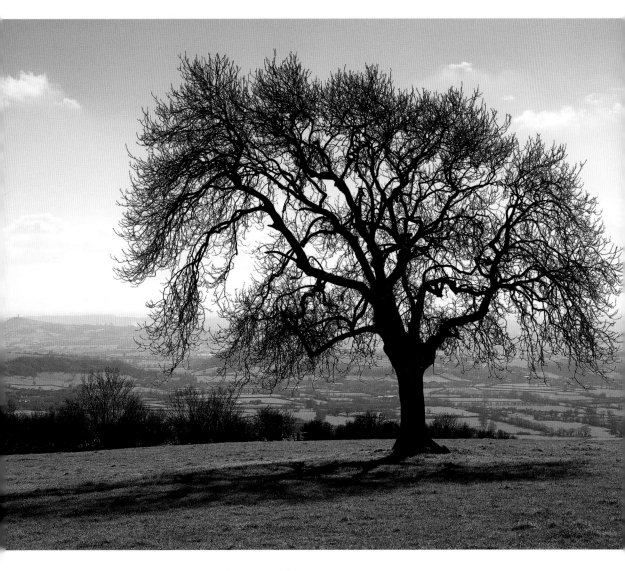

Threatened

above—An ash tree (Fraxinus), overlooking the Somerset Levels in England, shows its spectacular shape against a bright winter sky. Ash trees all over Europe are under threat from a disease called ash dieback.

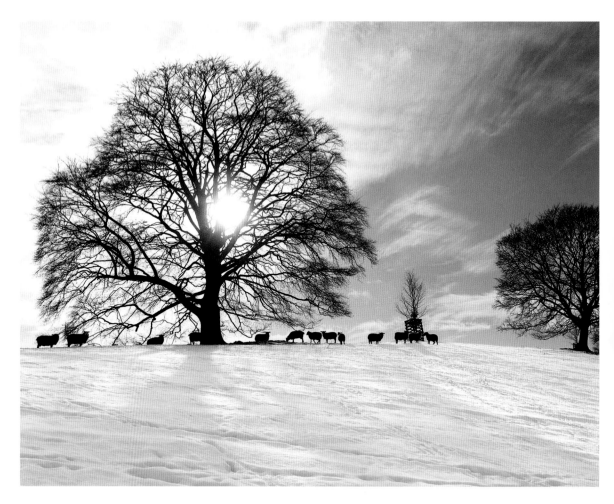

A Pastoral Winter Scene

above—Sheep gather around a majestic tree in the snow-covered Cotswold Hills, England. I think they wanted the high vantage point to feel safely away from me! After snow, this area is so quiet. All I could hear was the soft crunching of sheep feet in the snow.

Snow-Covered Conifer

below—This beautiful snow-covered conifer was planted in Victoria Park in Bath, England. I love the way the branches seem to splay out in all directions, plus they hang low to the ground. This was a magical day I won't forget in a hurry.

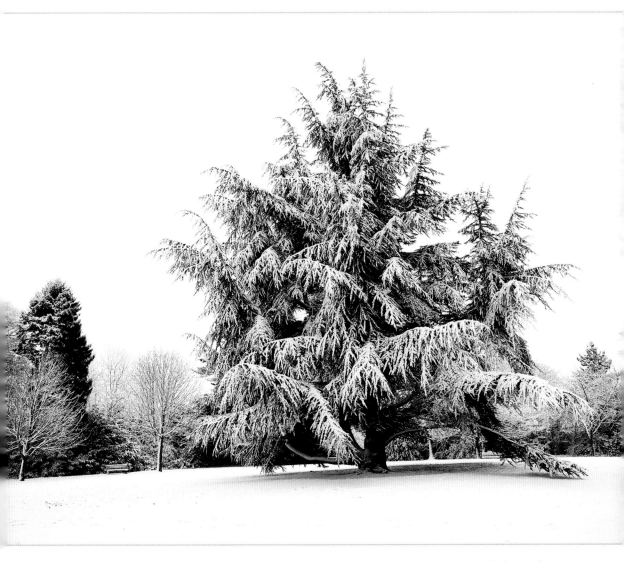

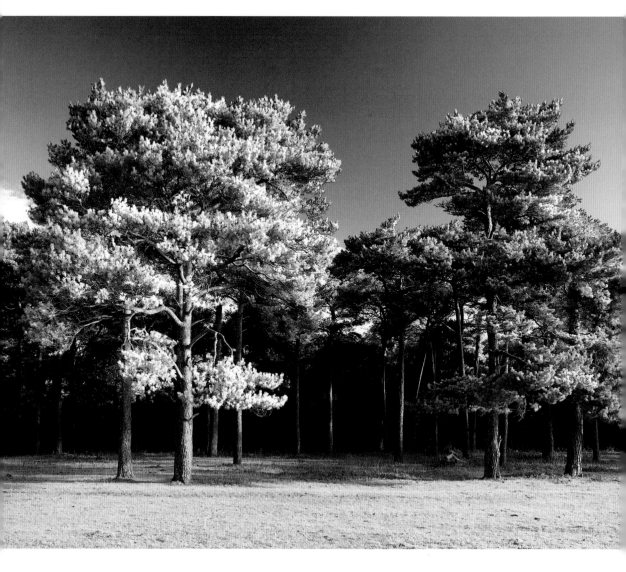

Scots Pine

above—I photographed this plantation of Scots pine trees (Pinus sylvestris) with a special tilt/shift wide-angle lens. This allows for adjustment to prevent the bendy distortion that is produced by most wide-angle lenses (where tree tops all curve towards the middle of the frame).

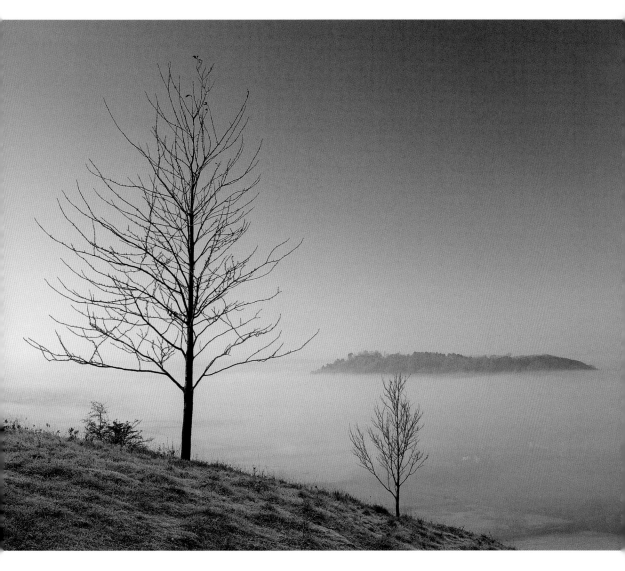

A Pleasing Shape

above—Sometimes, just the shape of trees is enough to make a great image. These dark, unidentified trees on the edge of a hill contrasted nicely with the misty valley below.

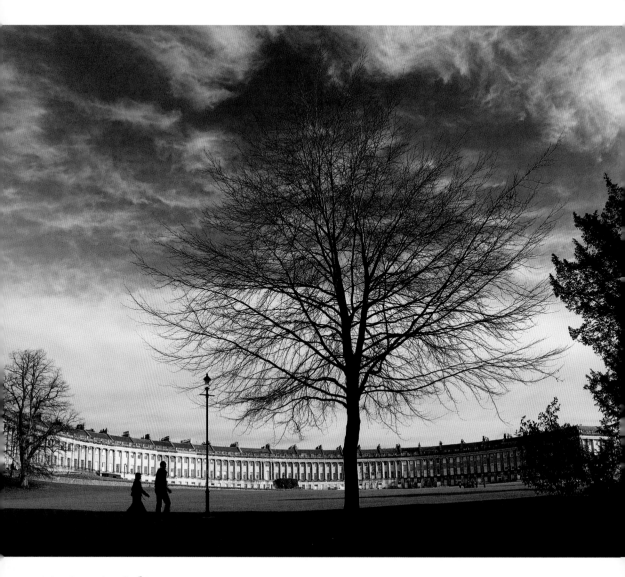

A Favorite Subject

above—This beech tree (Fagus sylvatica) is a favourite subject of mine in all seasons, but this image was created in the winter. The tree is planted in front of the world-famous Royal Crescent, a magnificent example of Georgian architecture in Bath, England. The tree makes a perfect foreground.

Lines of Trees

below—I love to see trees in the wild, but some of my best images are of trees planted in lines, like this row of snowy beech trees, photographed during the winter in Clifton, Bristol, England. I waited for the right people to walk into the best position and this couple unknowingly obliged.

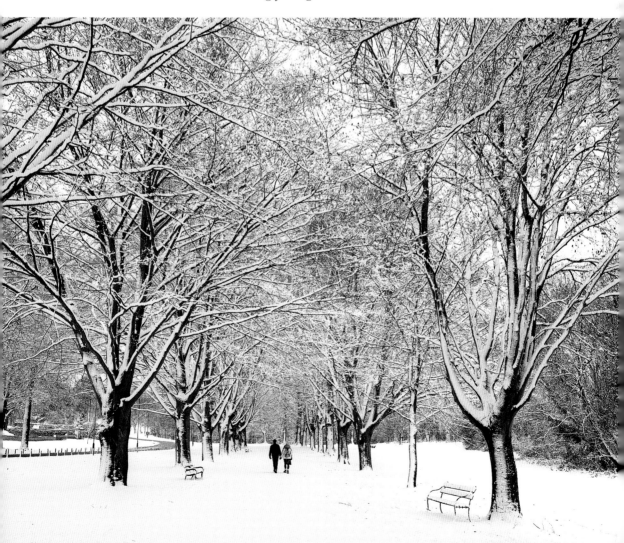

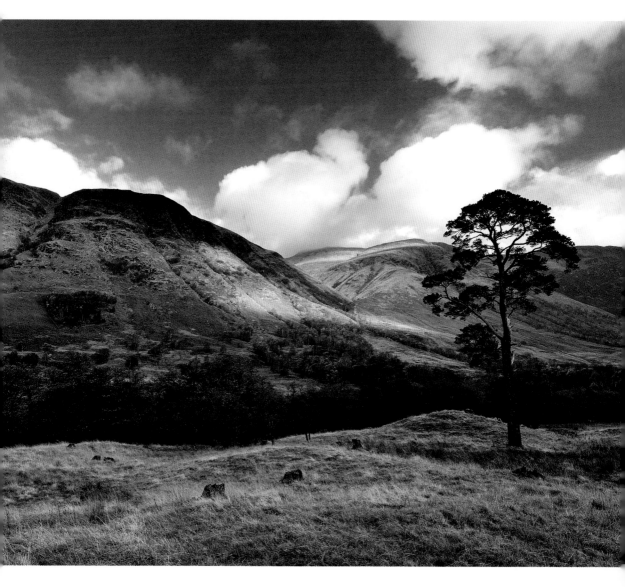

Somewhere Wild

above—This Scots pine tree (Pinus sylvestris) grows in Glen Nevis, the valley below Ben Nevis, Scotland (the highest mountain in Great Britain). Scots pine is an evergreen conifer, native to northern Europe. It is one of my favourite trees, because seeing them means I'm somewhere wild. You don't encounter them in cities!

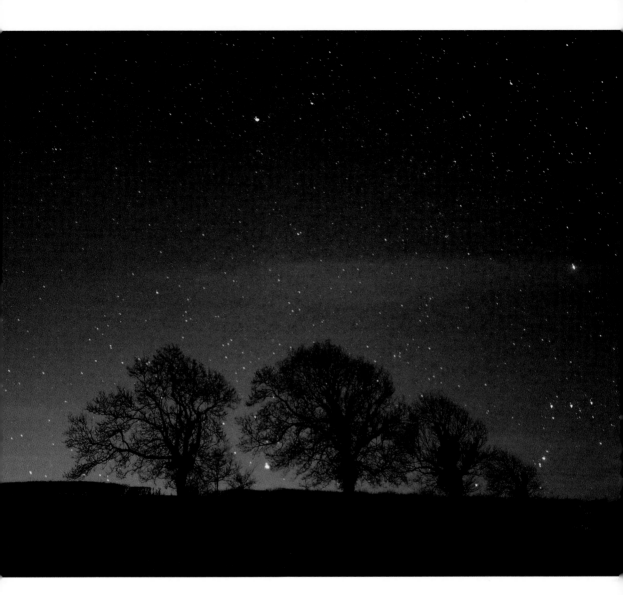

Starry Sky

above—On a winter night, these oak trees (Quercus robur) stretch up toward a star-studded sky. In winter, the large amount of ivy growing on these specimens can clearly be seen, adding extra girth to the trunks and branches.

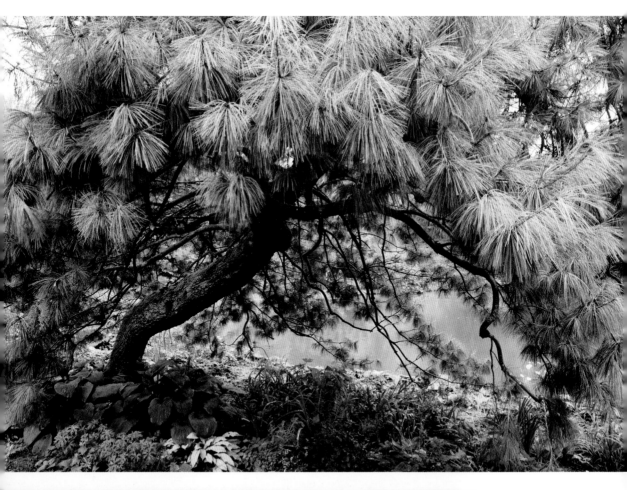

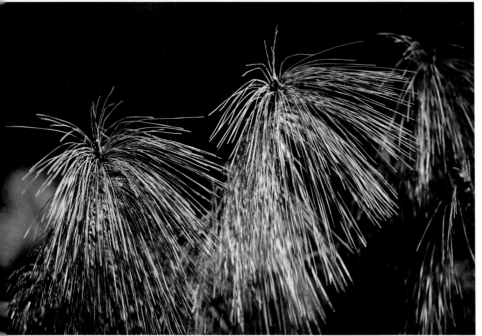

Bhutan Pine

above—This crooked tree is a Bhutan pine (Pinus wallichiana), which comes from the Himalayas region of India and the surrounding area (they're not normally crooked!).

left—The leaves and needles of the Bhutan pine have a very attractive drooping look, which I've always liked.

Pine Copse

below—This is a copse of pine trees on a small island on Beacons Reservoir in Brecon, Wales. I knew there was a good image here, but I had to walk around the extremely boggy edge until the composition was just right. I got soaked, muddy feet and trousers but also a good image for my troubles!

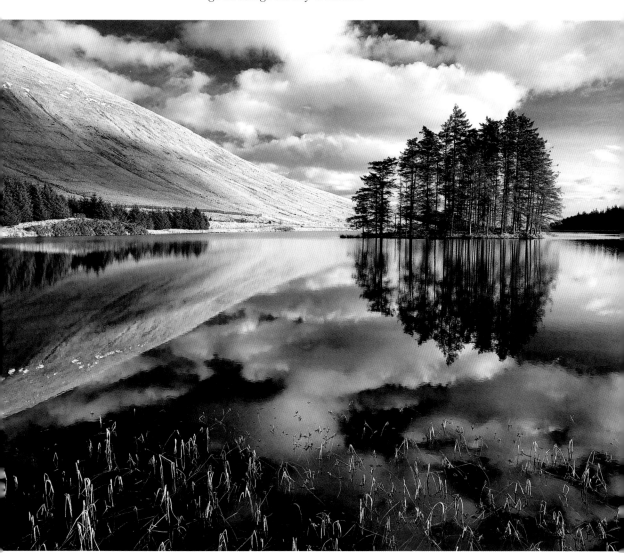

The Best Specimen

below—This beech tree (Fagus sylvatica) was the best shaped one I could find after looking upwards at several others, some of which had twisted or broken branches. Sometimes, it takes patient effort to get the very best tree images.

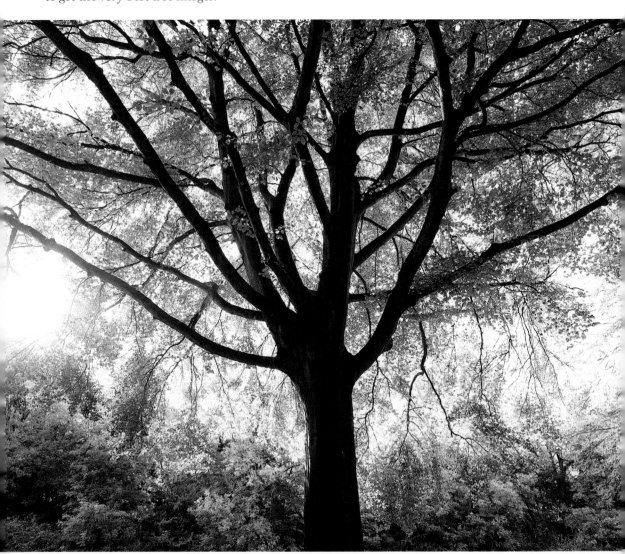

The Seven Sisters

below—Known locally as the Seven Sisters, this small line of beech trees (Fagus sylvatica) on Exmoor, England, are a favourite subject during any season.

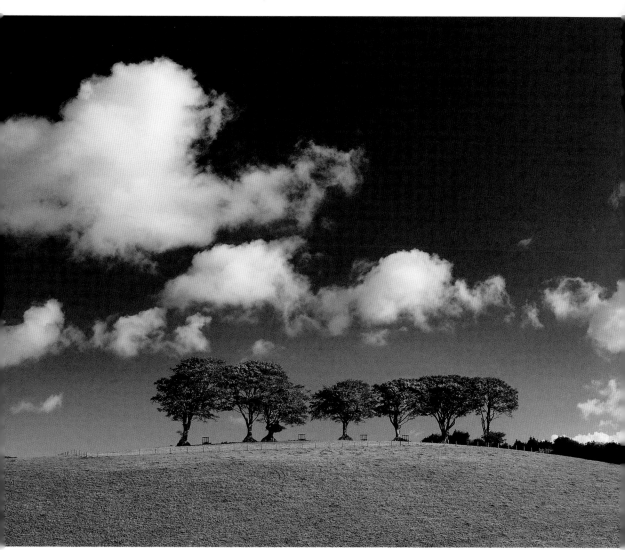

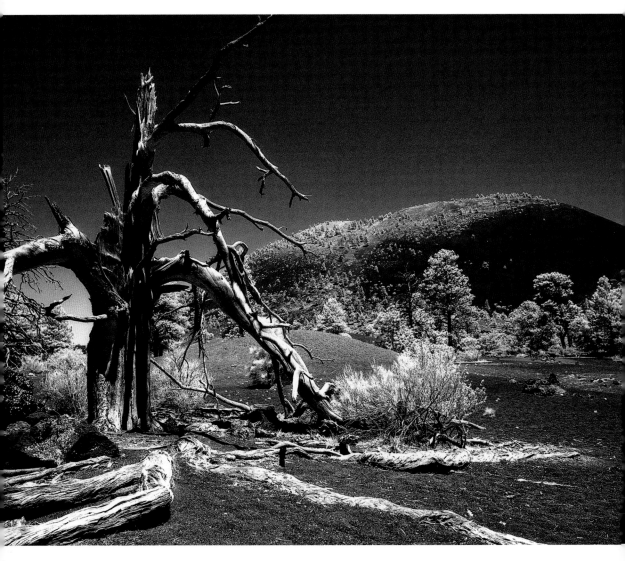

Sunset Crater

above—Although dead (whether from a lightning strike or simply old age), this tree near Sunset Crater, Arizona, still has character. I captured it with infrared film using a red filter, which emphasises the chlorophyl in the nearby foliage and adds contrast to the image.

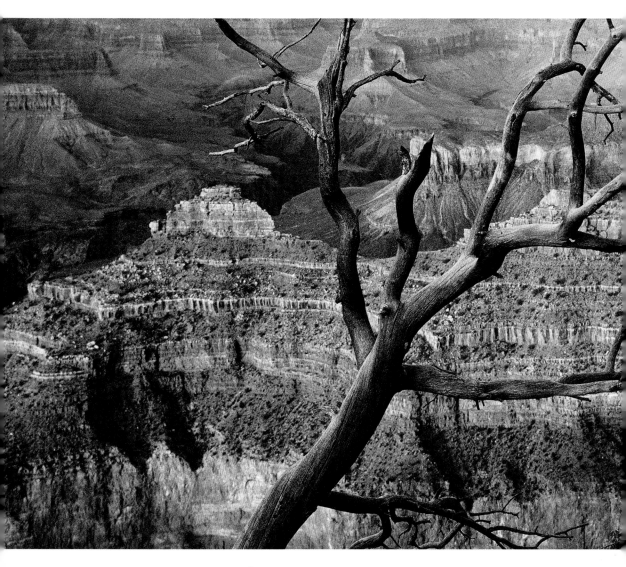

Grand Canyon

above—Here's another unidentified dead tree, this time by the edge of the Grand Canyon, in the United States. I looked around for quite a while for a focal point for this image before finding this twisted beauty. Images of the vast Grand Canyon often require a secondary subject like this to add interest and perspective.

Bleached by the Sun

below—This is a field of dead oak trees in England. Legend has it that, back in the 1600s, these trees were used to hang people. The trees lived until 1953 when the sea flooded the area, killing them. Bleached by the sun, the skeletons of the trees shine brightly in direct sunlight to show the texture of the bark and branches.

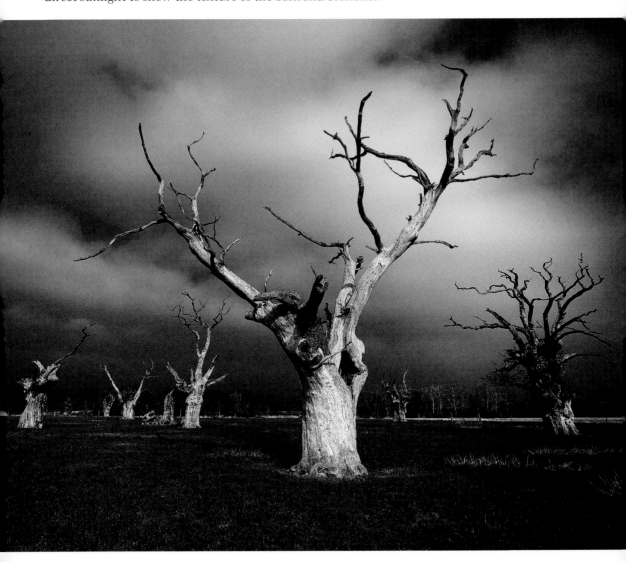

A Moody Sky

below—To create this image, I waited for cloud cover and changed the exposure to make the trees silhouetted and darker against the moody sky. This emphasised their spooky appearance.

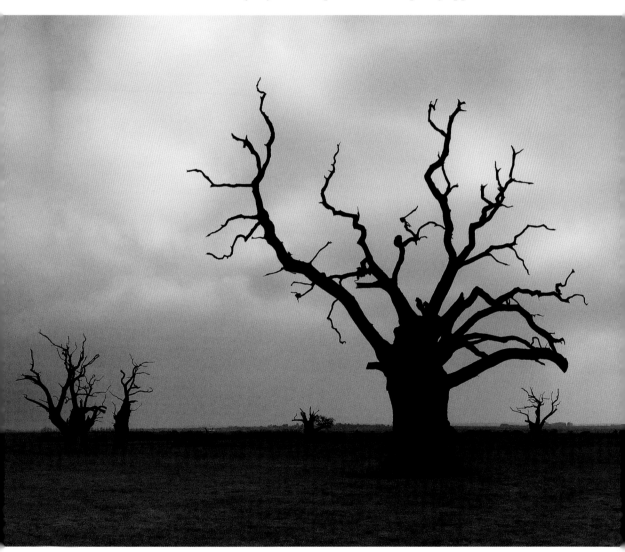

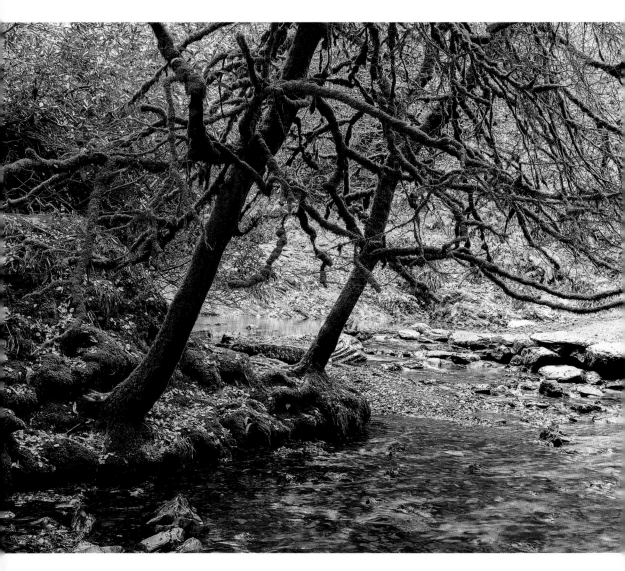

Covered in Moss

above—Moss has coated these dead trees in the
humid, damp, still conditions at the bottom of a
shady gorge in Devon, England. Trees are often
hosts to lichen, moss, and algae as well as ivy and
parasites like mistletoe.

Mistletoe

facing page—In winter, mistletoe is clearly visible
on deciduous trees. This tree looks as though it
has been reduced to simply being a host for the
mistletoe—to supply water and nutrients and
provide the physical support of the trunk.

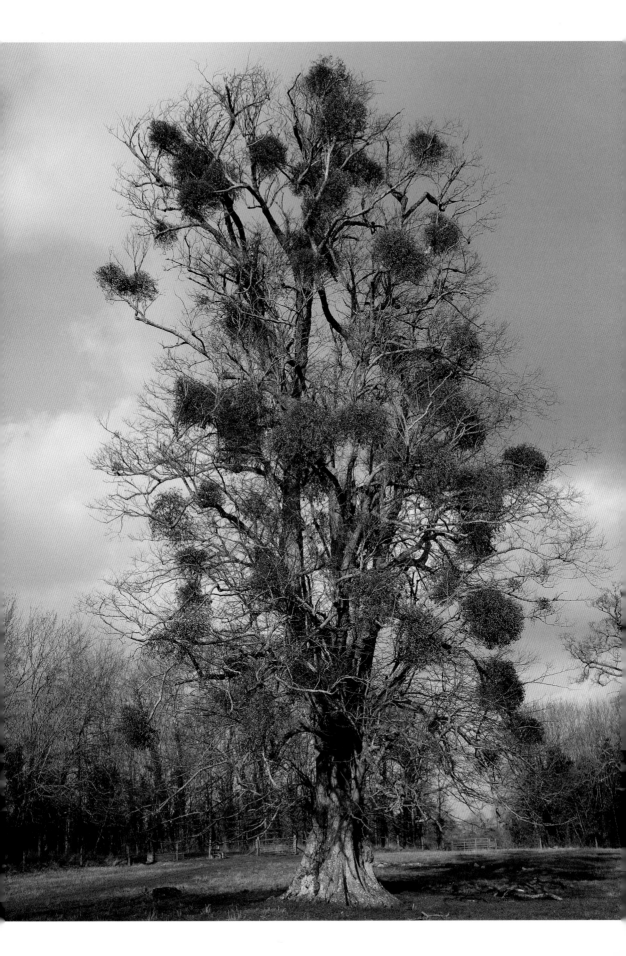

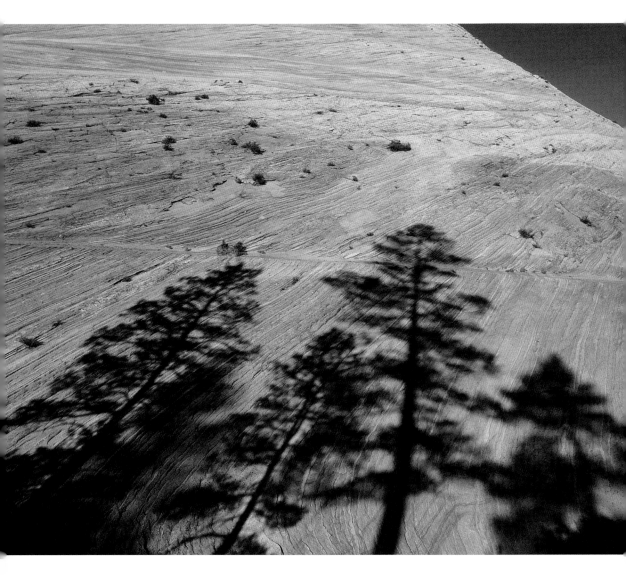

Ponderosa Pines

above—The great shapes of these ponderosa pines (Pinus ponderosa) created beautiful shadows on a nearby sandstone butte in Zion National Park, Utah. They can grow up to 50m tall.

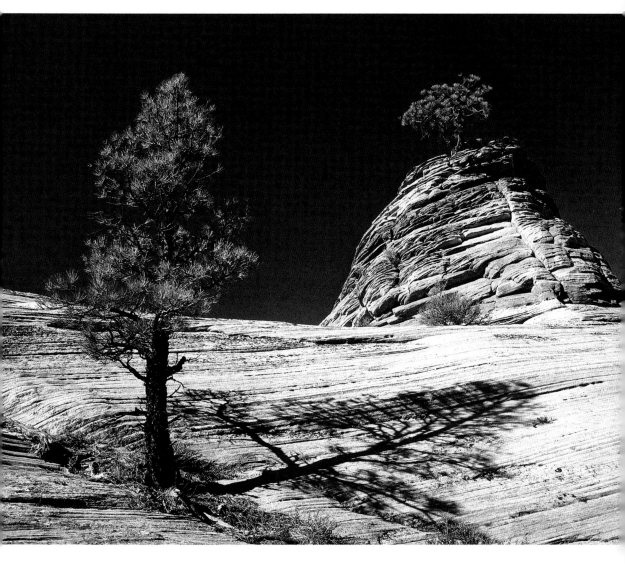

Stunted and Twisted

above—Perched in precarious positions in Zion National Park, Utah, these ponderosa pines stay fairly stunted and twisted out of shape. It's a wonder they survive the cold winters in this part of Utah— but luckily they do.

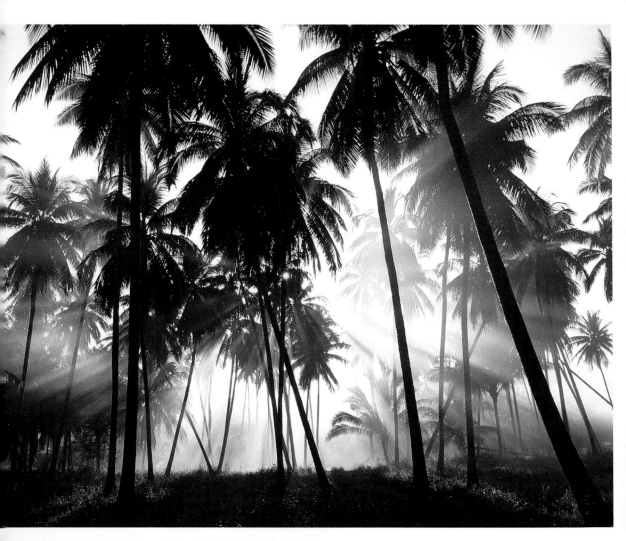

Palm Trees in Thailand

above—Palm trees are seen through dawn mist in Koh Samui, Thailand. Most palms are found in tropical and sub-tropical climates where they thrive. Some of the trees shown are coconut palms, which are known to kill several people each year when large coconuts fall on their heads. It has been reported that, in some years, more people die from coconut falls than are killed by sharks!

left—More palm trees in Thailand, this time photographed at dusk.

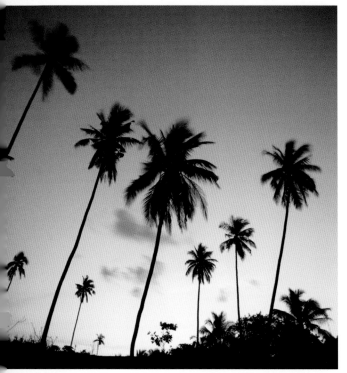

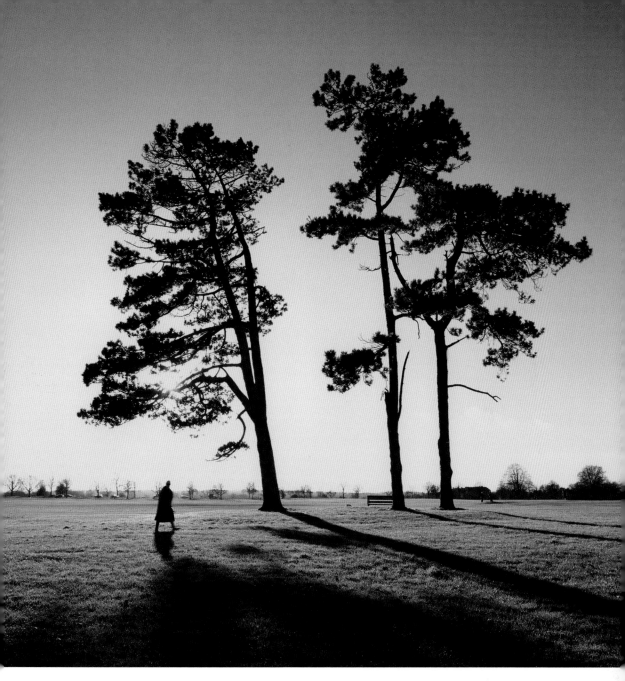

Pine Tree Silhouettes

above—This small group of pine trees looked dramatic against the light; I took several shots until a woman entered the scene. I don't normally take images with people, but she helps to give the image a sense of scale.

right—The same trees photographed at night with a full moon.

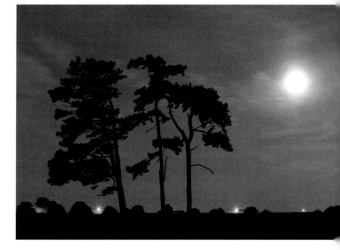

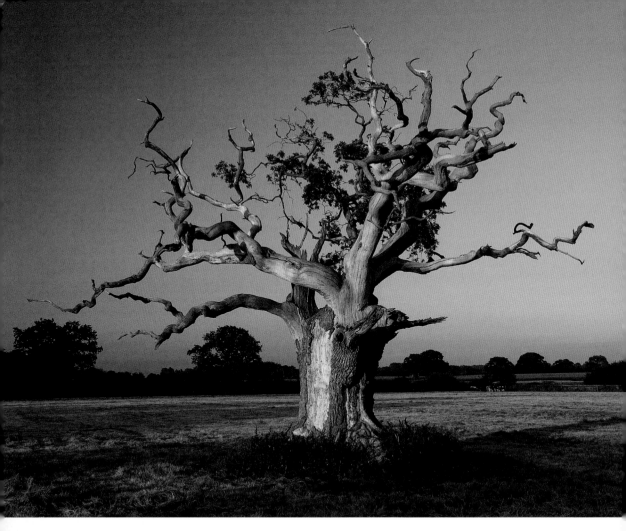

Grand Old Oaks

right—This old oak specimen (Quercus robur) is still just about hanging onto life, producing a few small branches of leaves every year. Grand old oaks make a splendid sight, even when dead—but I hope this one hangs on for many more years.

left—It didn't take long before these inquisitive young bulls came over to see what I was doing!

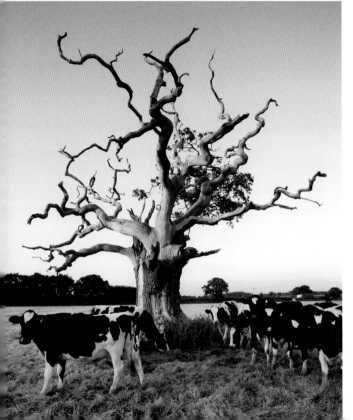

A Younger Oak

below—A much younger solitary oak tree stands on the top of a hill in Somerset, England. If I had my way, solitary trees (or groups of three) would be planted on every hill. They complete a view perfectly.

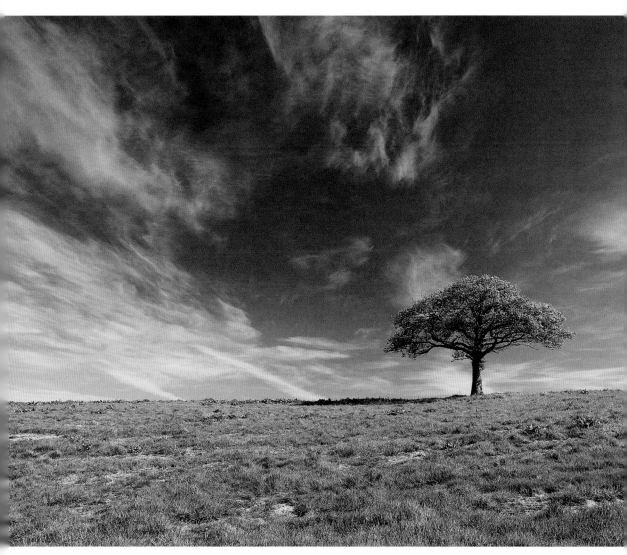

A Rare Hoarfrost

below and right—Below, a lone
Scots pine (Pinus syvestris)
was photographed during a
hoarfrost—a rare occurrence in
southern England. The frost
coats trees like powdery snow,
making an ephemeral but
wonderful photography sub-
ject. To the right is a different
view from the same location.

facing page, bottom—The hoarfrost
lasted all day because the sun
didn't shine. This night scene,
in Bristol, England, shows
trees in a local park. It was an
unforgettable day.

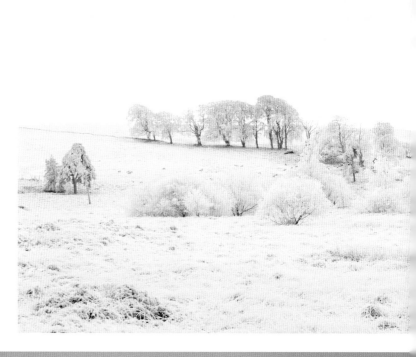

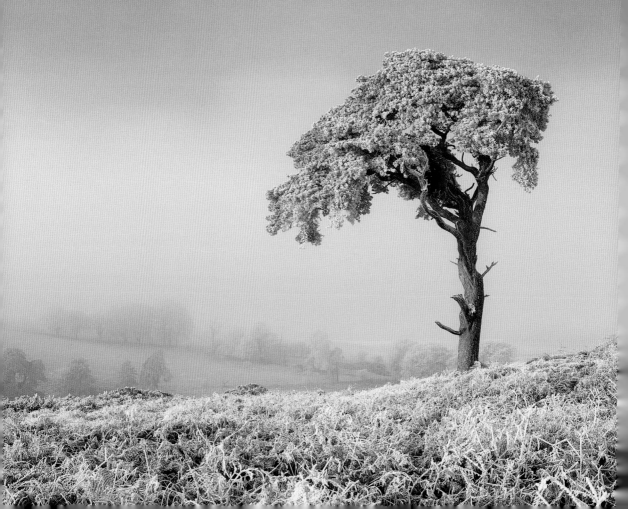

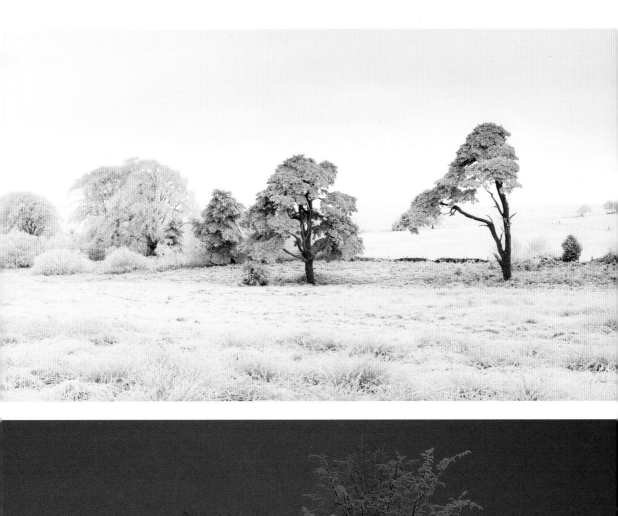

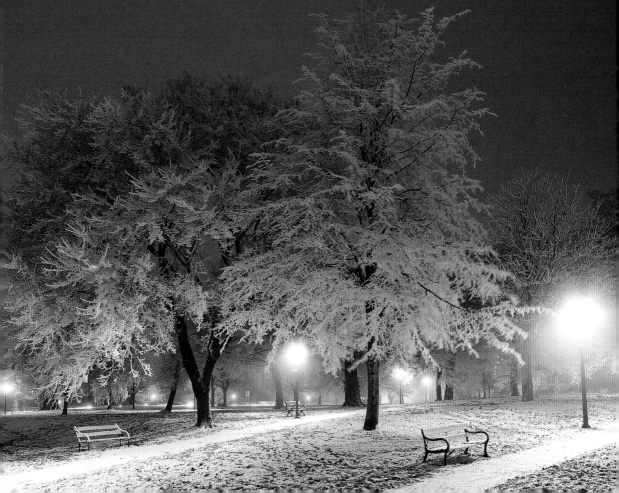

A Focal Point

below—A hilltop is an ideal place to plant three pine trees. See how they make the dawn view complete by giving a focal point to the scene? They are great for walkers and photographers (and I'm both, like a lot of people).

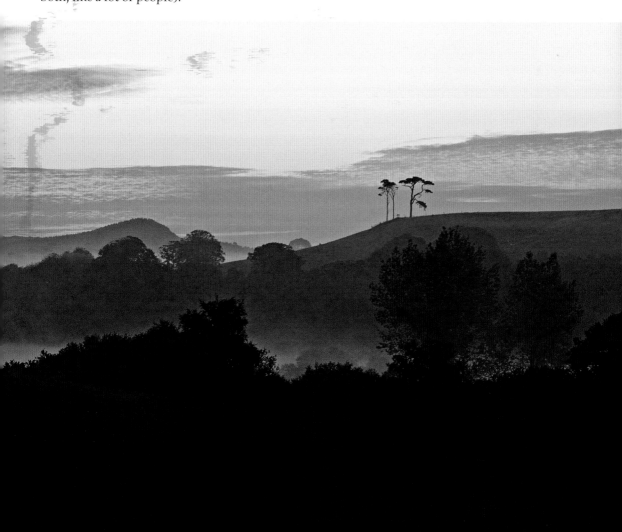

A Landmark

below—Here are some more pine trees planted on top of a hill. I use these trees to get my bearings when I'm walking around the hills here, near the south coast of England.

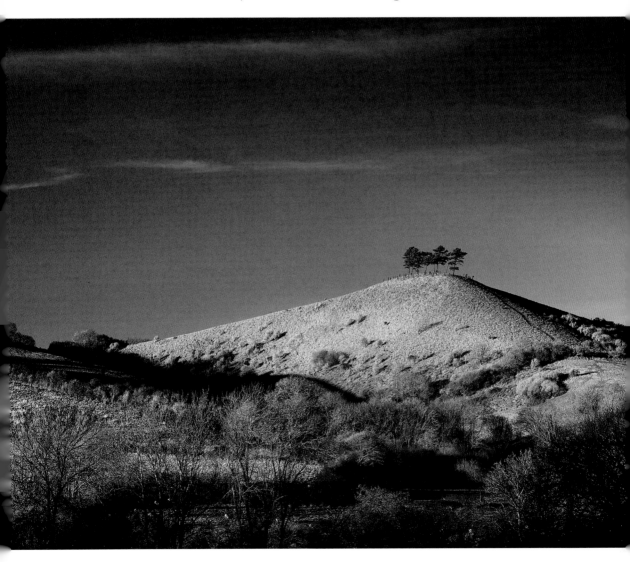

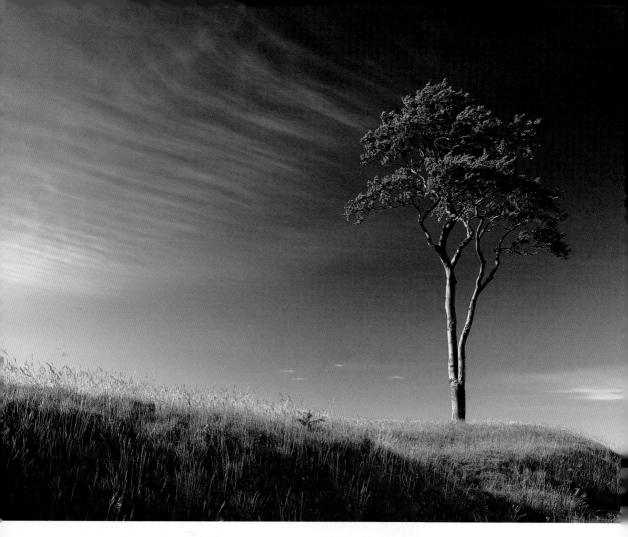

Against the Elements

above—This Beech tree (Fagus sylvatica) on top of a hill in Wiltshire, England, has to struggle against the elements if it wants to grow to maturity in its exposed location. The winds up here can be strong at any time of the year. The "combed" clouds complete the image perfectly.

left—Some older Beech trees have managed to grow large on the same hill.

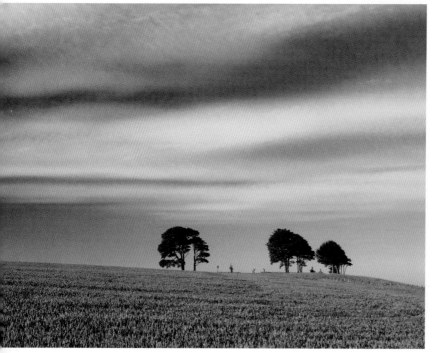

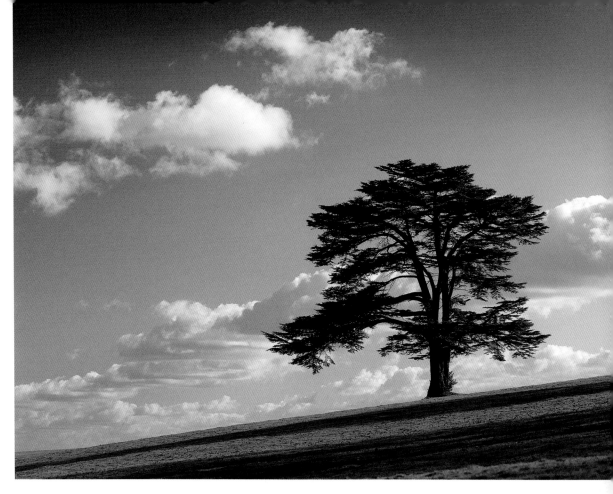

Cedar of Lebanon

above and below—Cedar of Lebanon (Cedrus libani) is a majestic evergreen conifer that is native to the Lebanon area and the eastern coast of the Mediterranean Sea. Cedar wood is used as an insect repellent in its native Lebanon. It is definitely one of the world's most beautiful trees. Above is a beautifully solitary cedar. The image below shows an avenue of cedar of Lebanon trees at Butleigh, England. These were planted in the 19th century.

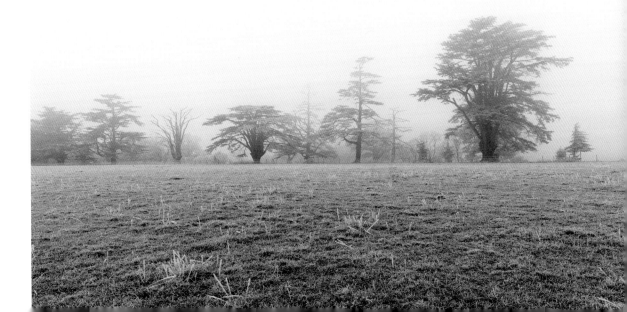

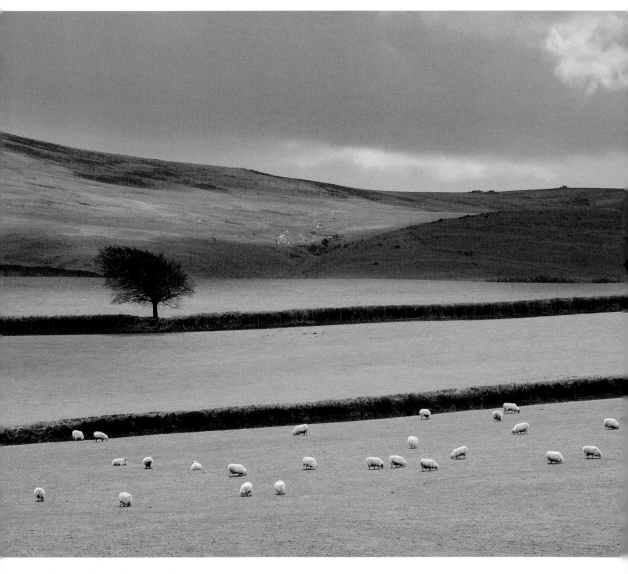

Shaped by the Wind

above—I photographed this elm tree in winter on Dartmoor, England. This one has been shaped by the direction of the prevailing westerly winds. Trees can be a haven for livestock, giving shelter from rain and sun (it does get sunny *sometimes* in England!).

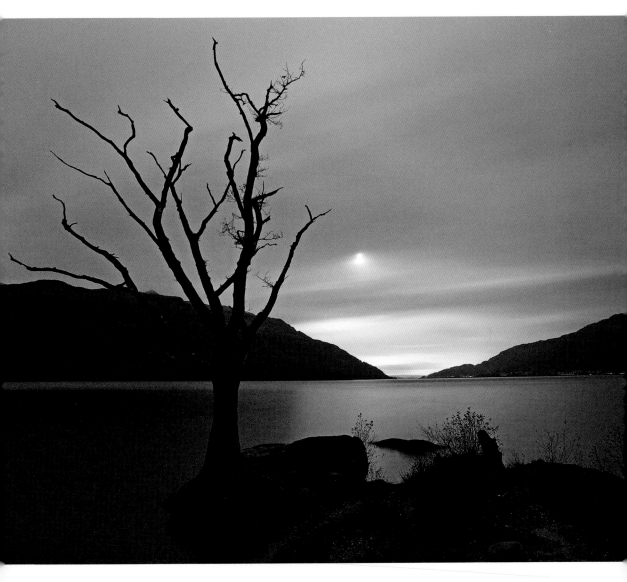

Moonrise

above—Even dead trees create great shapes, which can make a view complete. Trees have such character, and solitary trees make a good focal point. This unidentified tree is on the shore of Loch Lomond, Scotland, and was photographed at night with a rising moon behind it.

Mass Planting

below—Pines are often planted en masse to supply the timber industry with the soft, easily workable wood commonly used in furniture. Some species have delicious seeds (pine nuts) that are used in cooking; they are great for stir-fries and with pasta, although I often eat them on their own

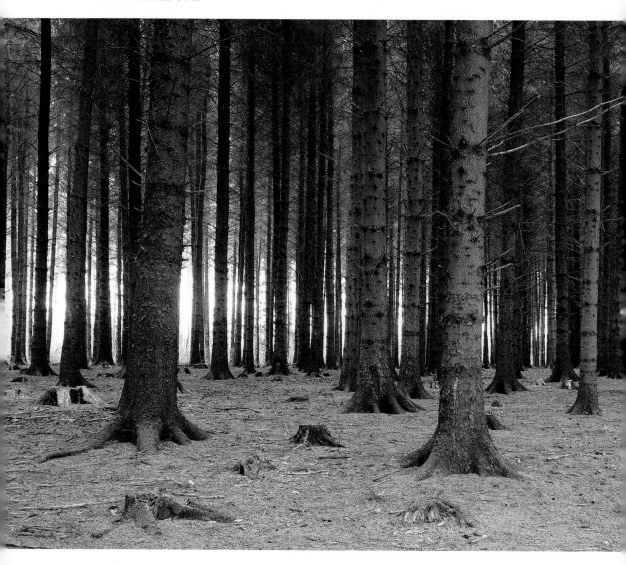

Texture and Detail

below—I was drawn to the texture of the detailed trunks of these pine trees, which works so well in an image that will be presented in black & white.

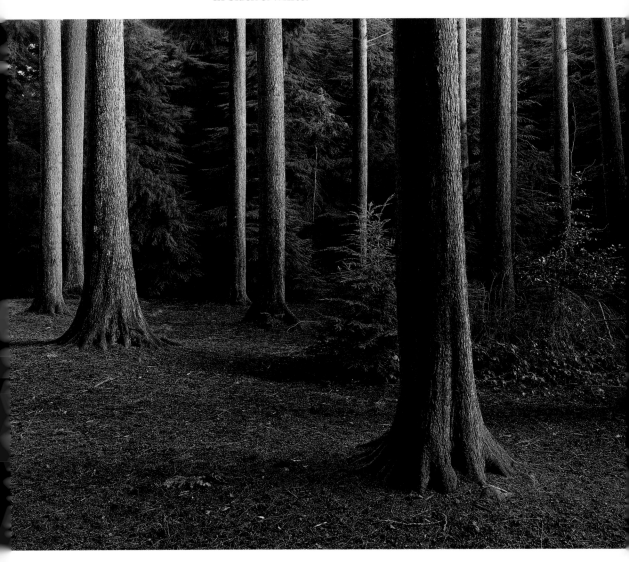

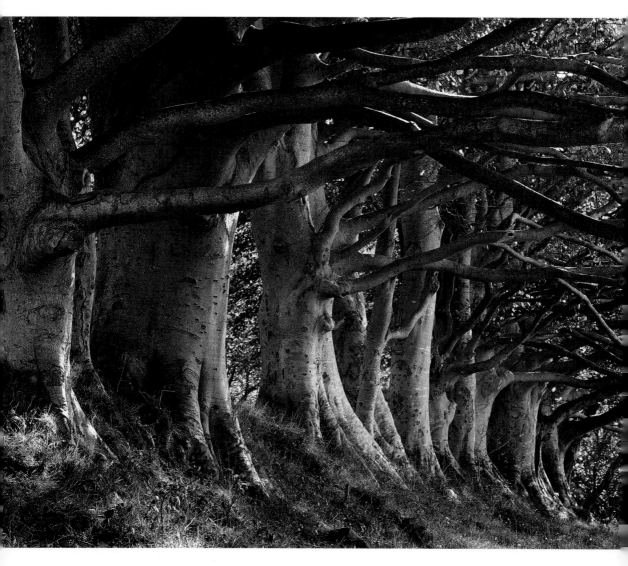

A Row of Beech Trees

above—Here we see a closely detailed view of a tight row of beech trees (Fagus sylvatica). These were grown on the top of a hill to make a boundary and provide shelter for livestock. I visit these regularly on walks over the Mendip Hills in Somerset, England, near my home. I love the way the branches all reach out towards the south, where the sun predominantly is.

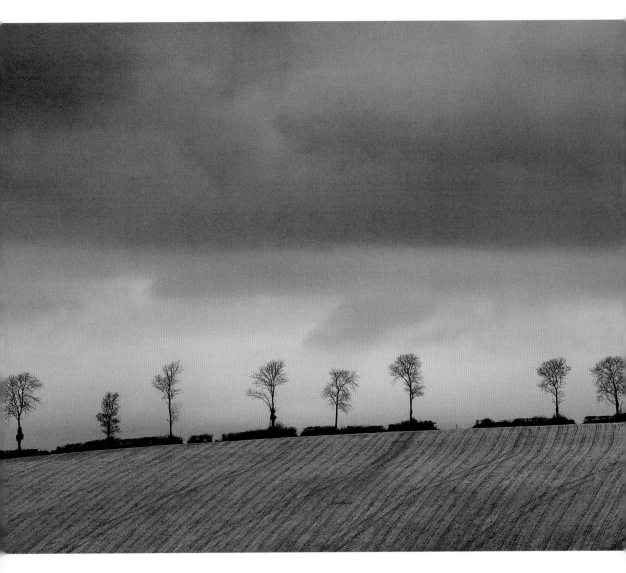

A Different Row of Beech Trees

above—In contrast, these beech trees (Fagus sylvatica) were planted much further apart—but they still make a spectacular sight. The ploughed lines leading down from the trees adds extra interest to the image.

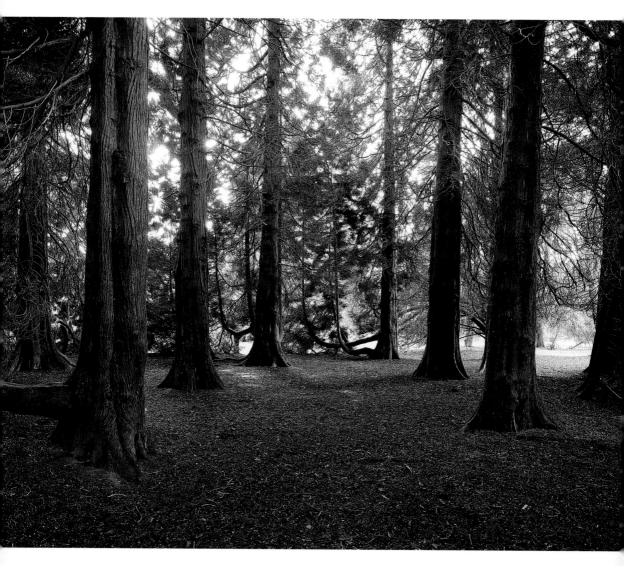

Western Red Cedar

above—Western red cedar (Thuja plicata) is a large conifer, which has some of the best wood for cladding, decking, fencing, or roofing. It's a spectacular tree, often growing in groups that appear as one tree from the outside as the foliage "knits" together

Sunlight Bursting Through

below—Sunlight bursts through trees at dawn in Wales. With early morning mist, low sun produces separate rays that make a great image even on their own.

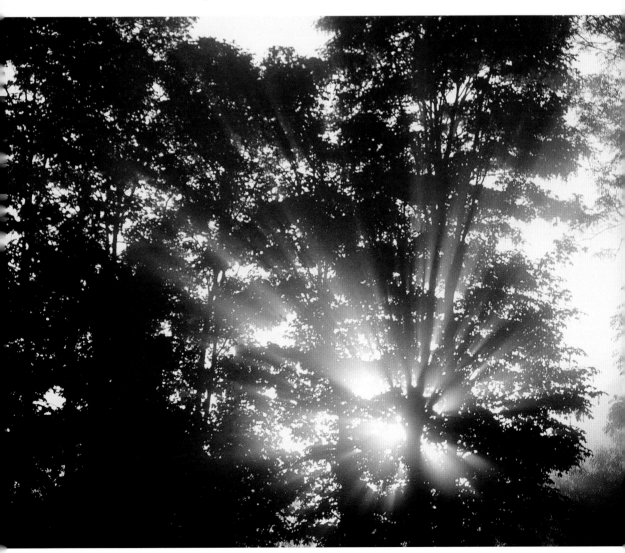

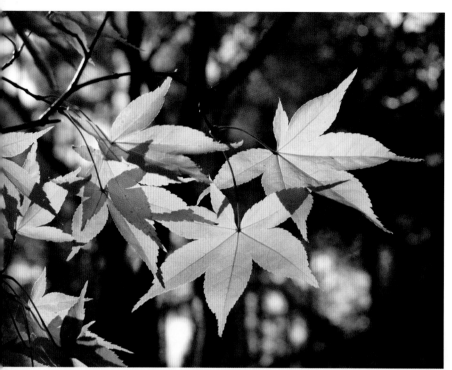

Contre Jour

below—This is a maple tree (Acer palmatum) in an arboretum, planted in shelter amongst taller trees, where these specimens thrive best. I photographed it "contre jour" (against the light) to give the image good contrast. Black & white images look more dramatic with high contrast.

left—Maple leaves.

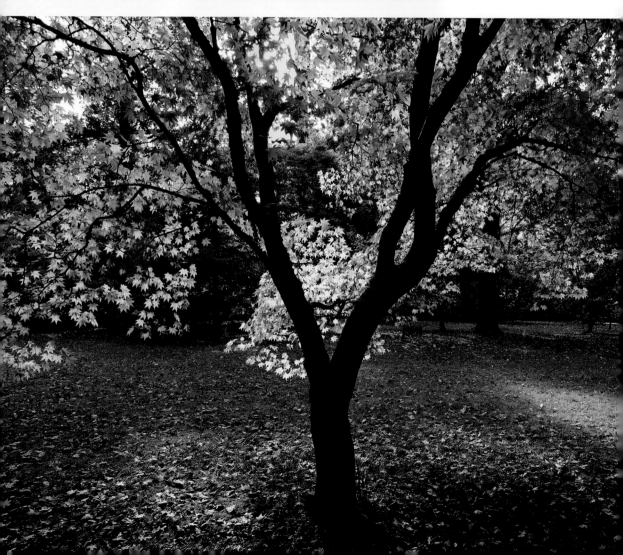

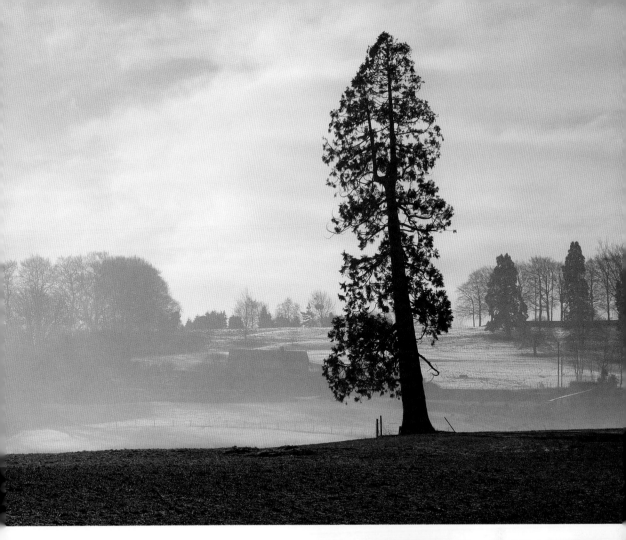

Giant Redwood

above—Giant redwoods (Sequoiadendron giganteum) may not be the tallest trees in the world but they are the largest by volume, reaching up to 95m in height and 12m in diameter. The largest known specimen is in its native California and known as "General Sherman." It is estimated to be 3,200 years old

right—Here I am, leaning against a giant redwood (Sequoiadendron giganteum) in Sequoia National Park, California.

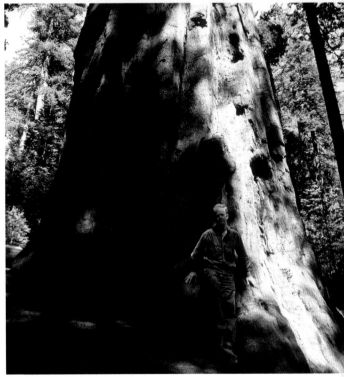

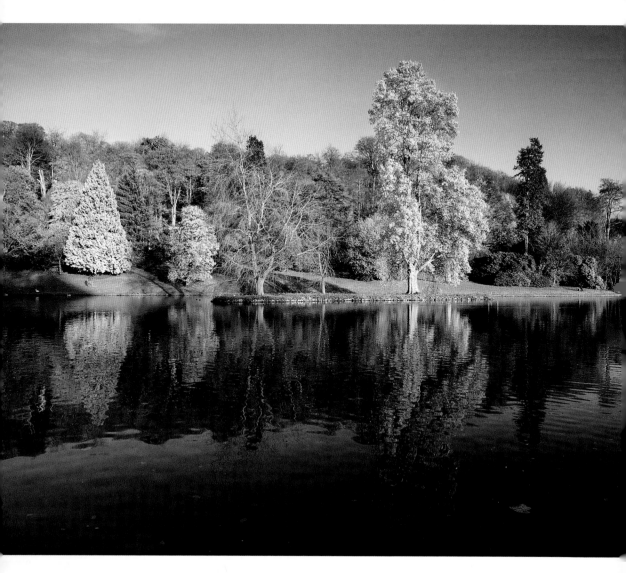

Henry Hoare

above—These trees, reflected in a lake in autumn, were ornamentally planted by Henry Hoare "The Magnificent"—a famous English garden designer in the 18th century. He said, "The greens should be ranged together in large masses as the shades are in painting: to contrast the dark masses with light ones, and to relieve each dark mass itself with a little sprinkling of lighter greens here and there." How right he was! The light and dark tones work so well together in colour or black & white.

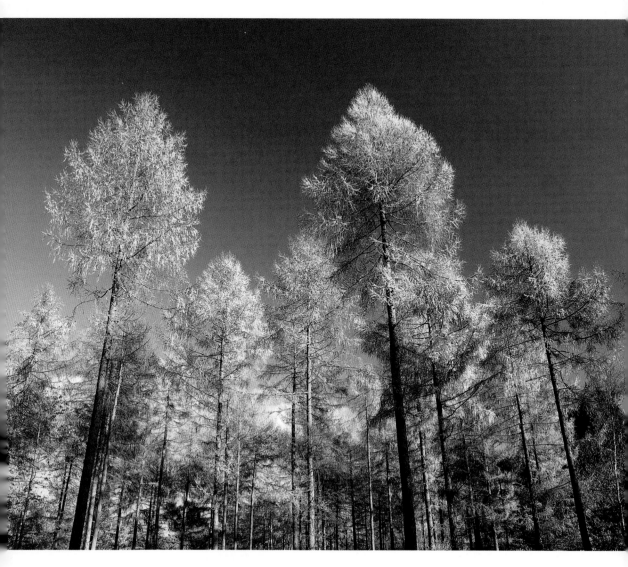

Larch

above—Here are more autumn trees. These are Larch (Larix), one of the few conifers that are deciduous. Their leaves turn to a bright yellow-orange before they fall. There are eleven species of larch.

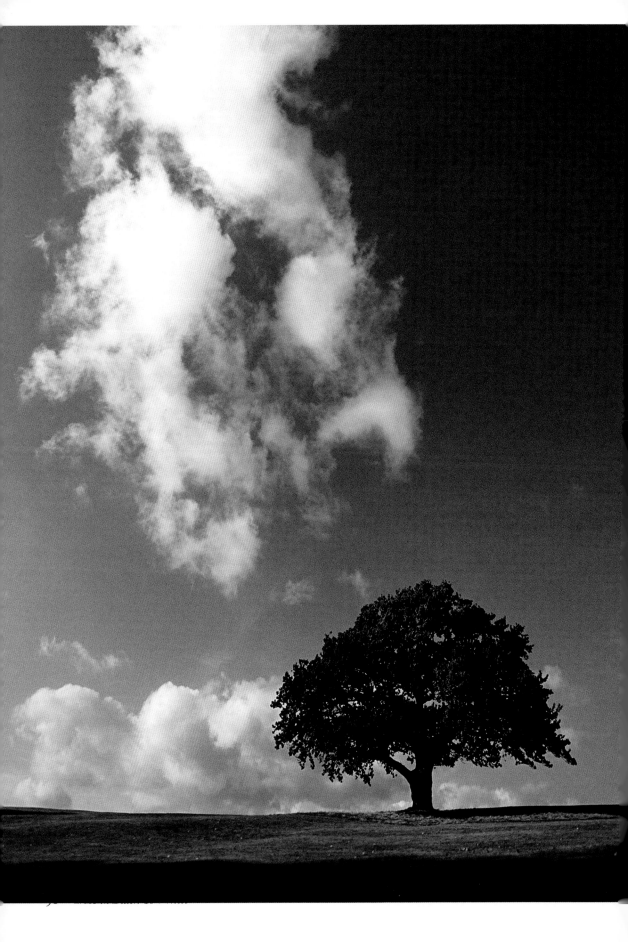

Norfolk Island Pine

right—The Norfolk Island pine (*Araucaria heterophylla*) is endemic to Norfolk Island, which is a small island near New Zealand. It is sometimes called the star pine, although it isn't a true pine tree. It has very attractively shaped foliage.

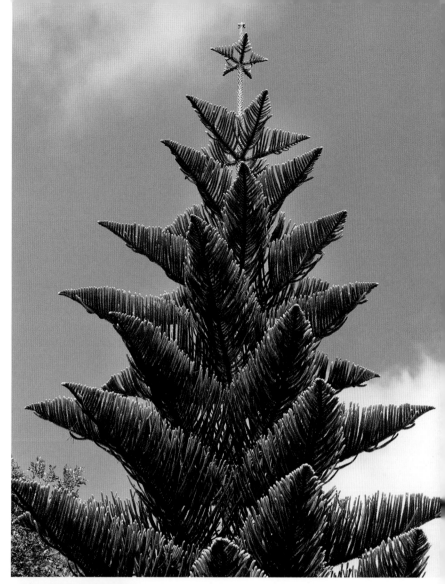

Oak in Summer and Autumn

facing page—This oak is a favourite of mine, as it grows on a golf course where I sometimes play. I hadn't managed to get a good image of it before—but on this bright summer's day, an unusually vertical cumulus cloud came along to complete the composition.

left—A fallen oak leaf in autumn, surrounded by bracket fungus.

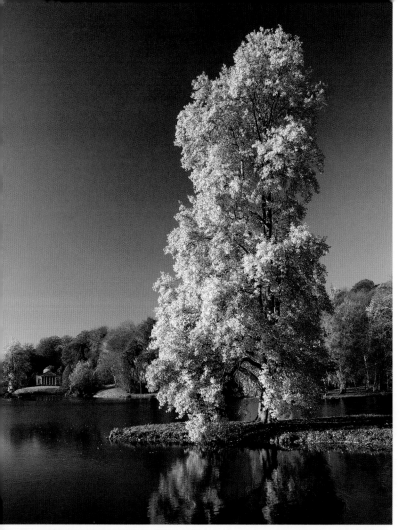

Tulip Tree

top left—The tulip tree (Liriodendron tulipifera) is a large tree with small flowers that vaguely resemble tulips, hence the name. Interestingly, the leaves also look like tulip flowers in profile.

bottom left—A dew-covered leaf, fallen from a tulip tree.

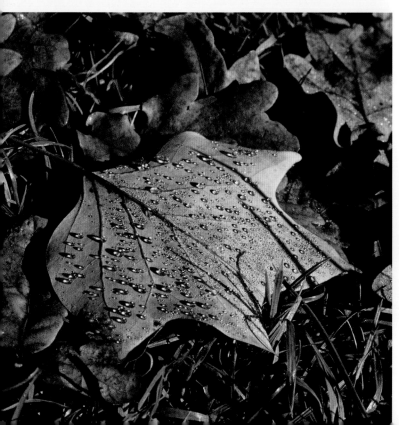

Red Bark

facing page— Japanese maple trees (Acer palmatum 'Beni Kawa') have coral-coloured bark and bright green leaves. These are small, slow-growing trees that are mainly cultivated for their colour. "Beni kawa" means "red bark" in Japanese.

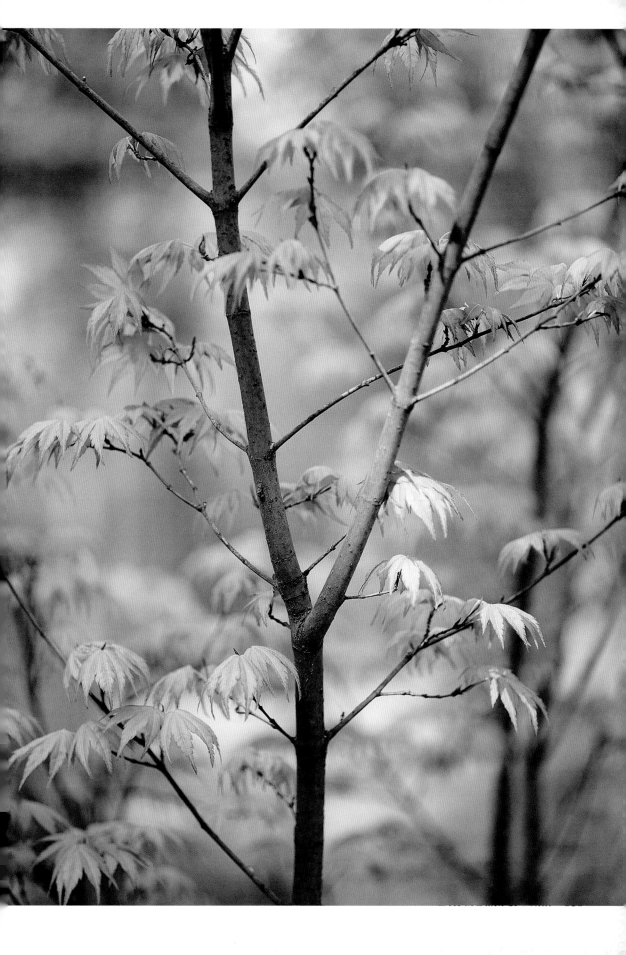

Willows

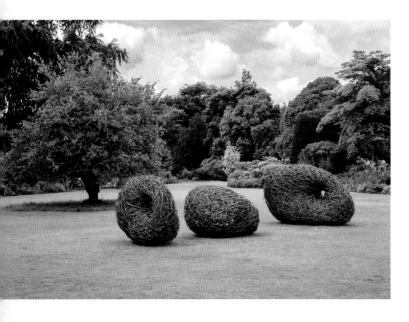

left—Willow has been used to make baskets for centuries. Nowadays, it's a popular material for making garden sculptures, like these in Forde Abbey, England.

below—Weeping willow is a beautiful tree, originally from China but found around the world. The most famous literary reference to the willow is probably William Shakespeare's "Willow Song" in *Othello*.

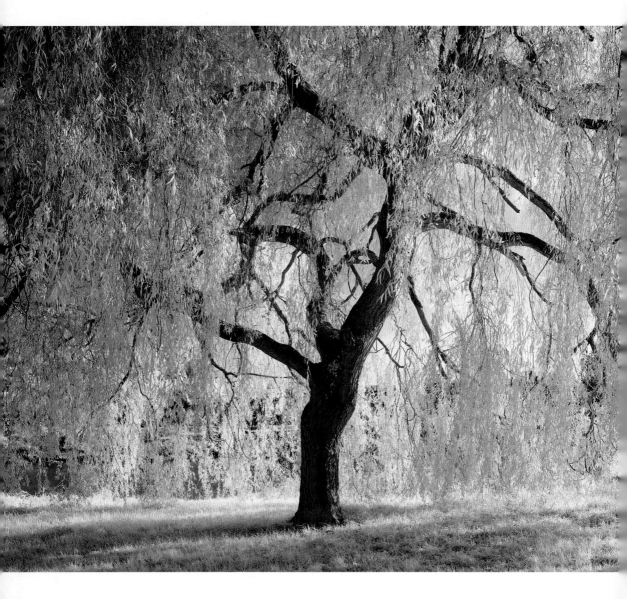

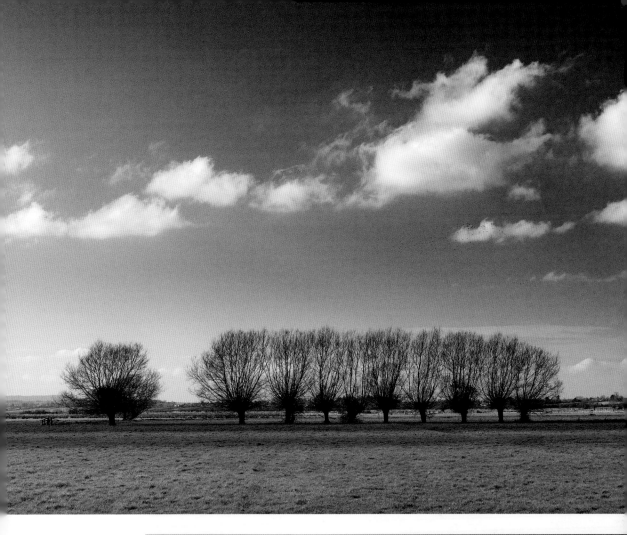

above and right—In England's low-lying Somerset Levels, willow trees (Salix) are grown to make baskets and sculptures—including "Willow Man" (*right*), the world's largest willow sculpture at 12m. Willow is even used to make coffins!

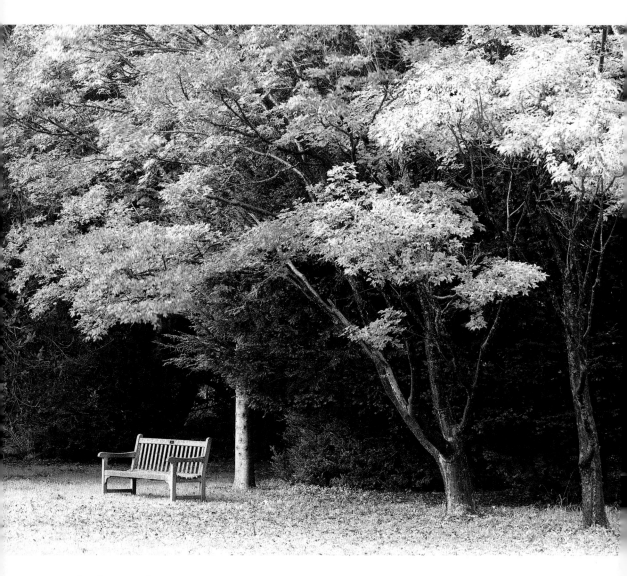

Paperbark Maple

above—A leisurely day walking around an arboretum in England led me to this paperbark maple tree (Acer griseum) above a bench. I spent some happy moments there, enjoying all the trees. Excursions like these bring peace and joy after days of working in the office!

Peeling Bark

below—Paperbark maple (Acer griseum) is a small tree native to China. It is much prized for its beautiful cinnamon-coloured bark, which peels thin like paper, making it a great textural photography subject.

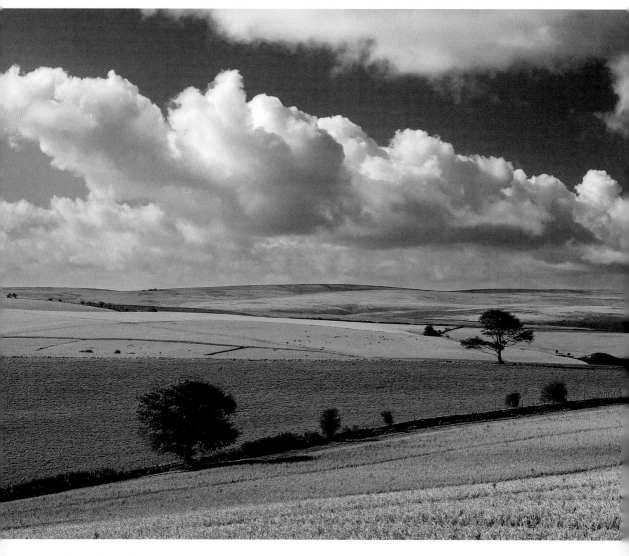

Oak and Birch

above—Here, we see an oak tree and a beech (Fagus sylvatica) on
exposed moorland (Exmoor, England). This is another location
I've photographed before several times, but this is the best shot—
thanks to the glorious cumulus clouds that were rolling by.

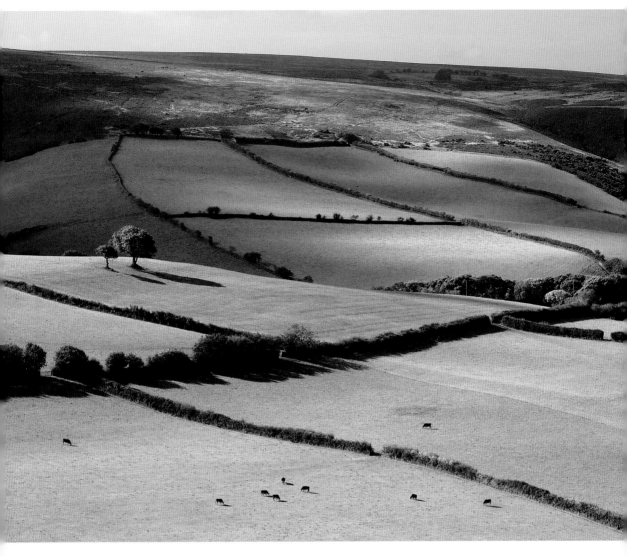

Across the Moor

above—This was shot on the same moor as the image on the facing page. In it, the two isolated trees prove how important they are as focal points in the landscape. Cover the trees with your hand and see how bleak it would look without them.

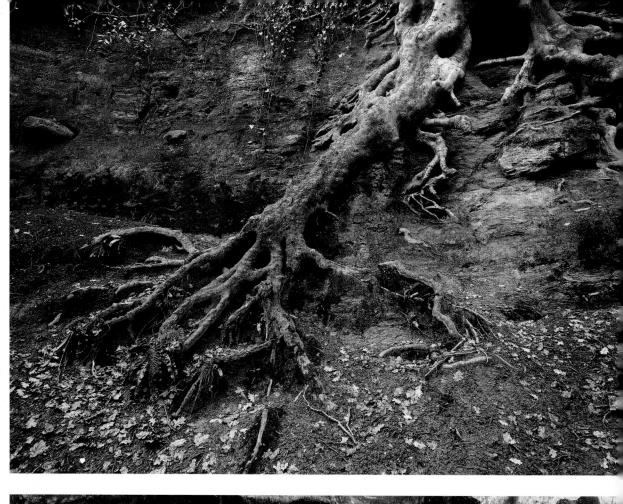
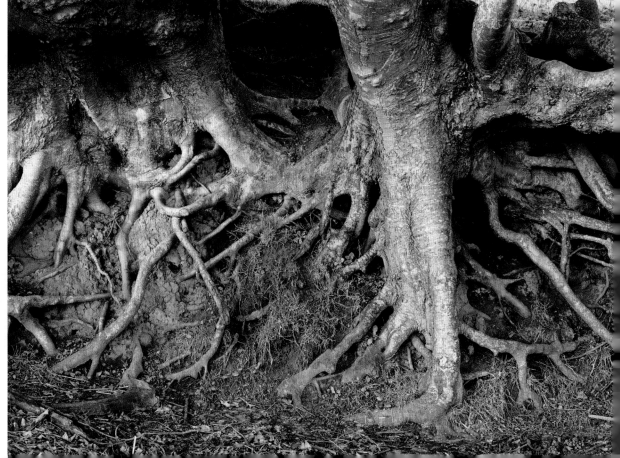

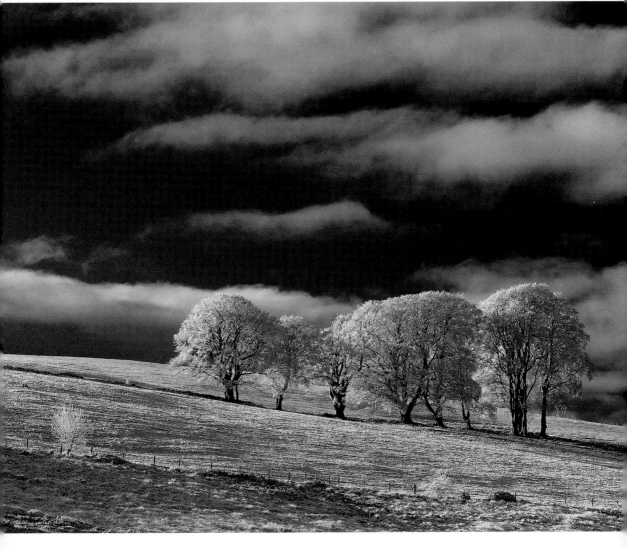

Winter Beech Trees

above—These beech trees (Fagus sylvatica) were dressed in snowy winter coats on a hillside in Southern England.

Beech Tree Roots

facing page, top—These roots are from a beech tree (Fagus sylvatica) on a steep shale slope in Glastonbury, England. They make an interesting feature as they appear to cling onto the rock.

facing page, bottom—More wonderful beech tree roots.

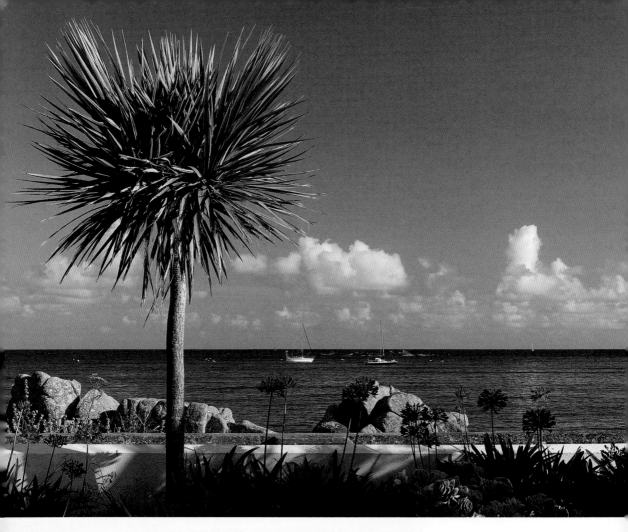

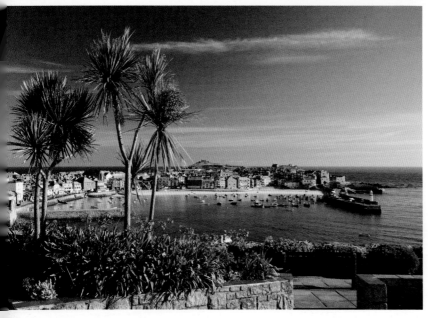

Palm Trees

above—The cabbage tree (Cordyline australis) is a small palm tree. It is originally from New Zealand but is now common in various countries of the world. It was named by the first settlers of New Zealand who watched the indigenous Maori people eat them.

left—Here are more cabbage trees, which create great shapes that look wonderful against the sky.

Beech Bark and Flowers

below—The smooth bark of these beech trees (Fagus sylvatica) was ideal for illuminating with a flashlight. The front trees get more light than the back ones, giving more depth to the image. The flowers in front are bluebells (Hyacinthoides non-scripta), which are quite common in woodlands across the United Kingdom.

right—Beech leaves on a branch above bluebells—but this time photographed in daylight.

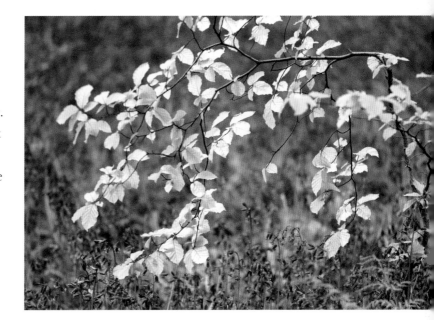

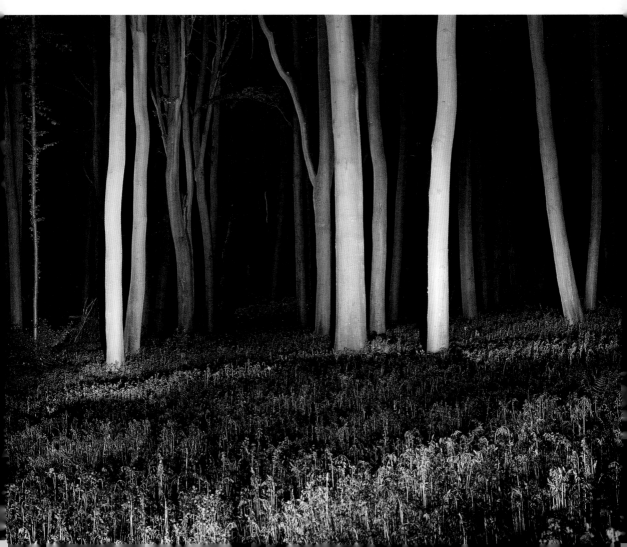

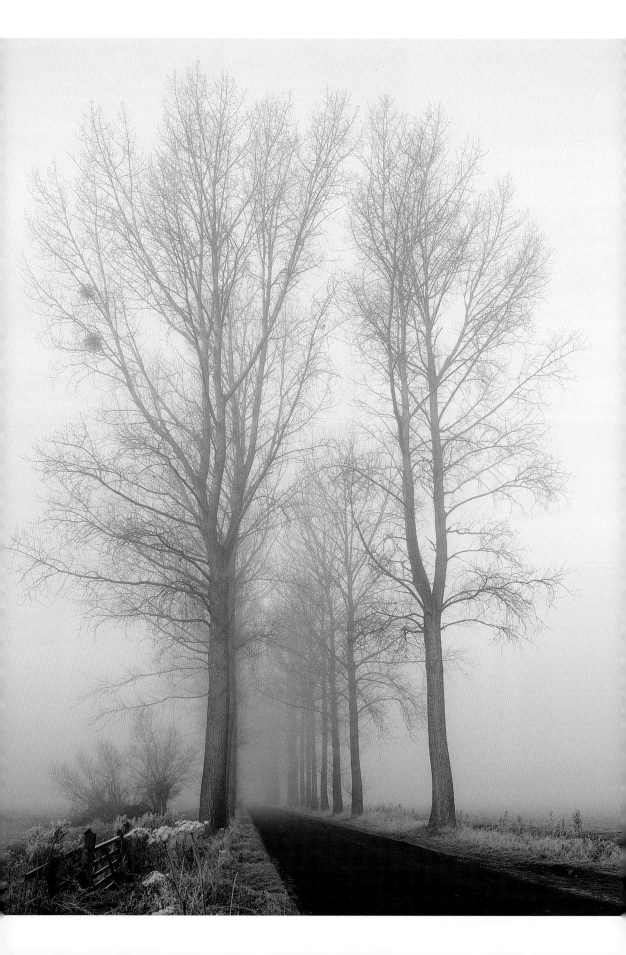

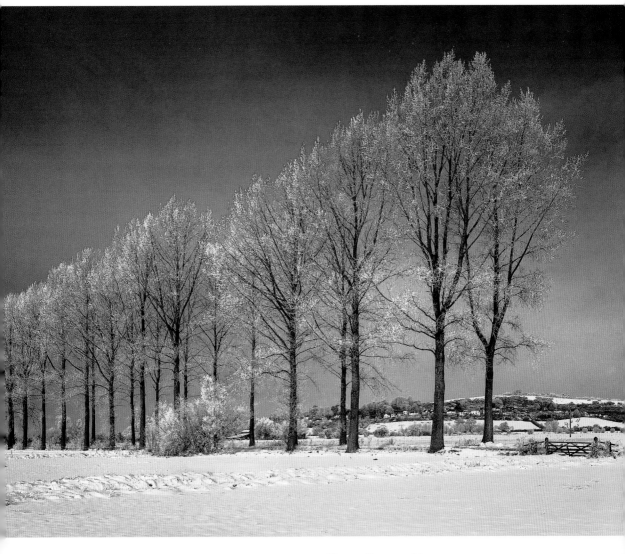

On a Snowy Day

above—These are the same poplar trees, but on a snowy day in January. This is just more proof that planted trees can often look much more dramatic than wild trees, at least from a photographic point of view.

A Misty Winter Day

facing page—These poplar trees are planted along each side of a road in Street, Somerset, England. What a splendid sight this was! I've driven down this road many times, but on this misty winter day they looked so good that I decided to walk among them for a while—after exploring all the photo opportunities, of course!

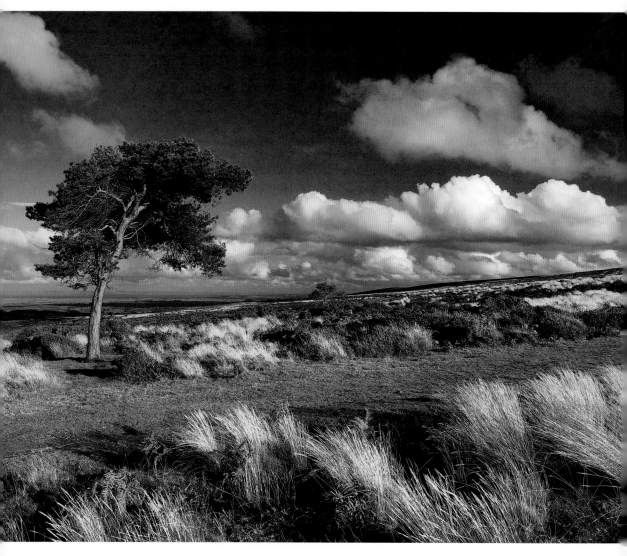

A Barren Hill

above—This Scots pine tree (Pinus sylvestris) stands on a barren,
windy hill. This image would be nothing without the great shape
of the tree—but what makes it for me are the various textures. I
like how the bright, grassy area contrasts with darker tones and, of
course, the clouds.

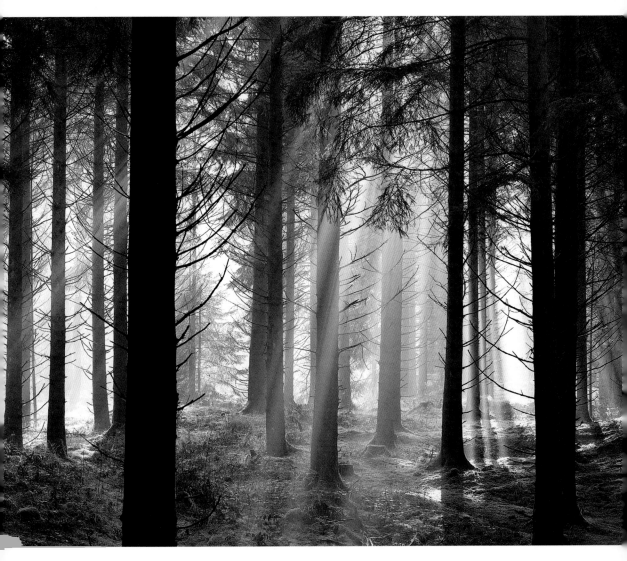

Sunbeams Through Mist

above—A pine forest becomes a magical place when you add early morning mist with bright sunbeams illuminating it from different sides. If you've never seen this spectacle in real life, I would whole-heartedly recommend it. I can only give a hint of the atmosphere in the picture, but the sound of the birds breaking the silence and the fresh smells make it almost a spiritual experience.

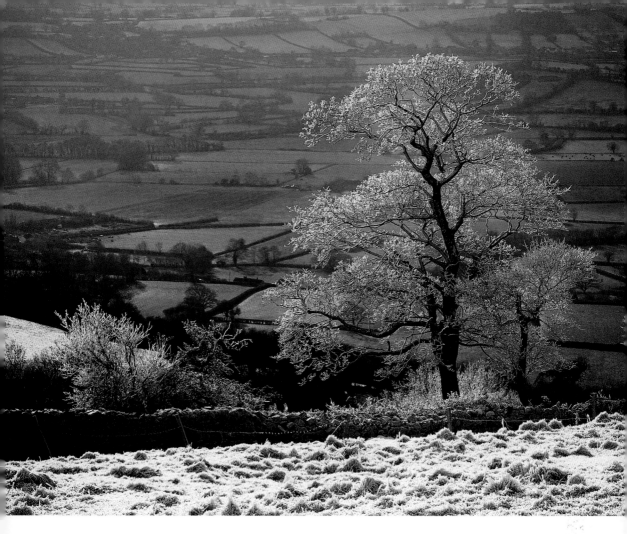

Frosty Oak

above—This oak tree is covered in hoarfrost, which makes it stand out well from the darker background. There was no frost at all on the distant landscape because it is lower-lying ground (at very near sea level, in fact).

Frosty Maples

facing page, top—These two maple trees (Sycamore) were standing together like friends during the same hoarfrost as in the photo above. I've only ever seen such a beautiful frost once in thirty-seven years of photography. Even without the pictures, it will be engraved on my memory for as long as I last.

facing page, bottom—A fallen maple leaf covered in frost.

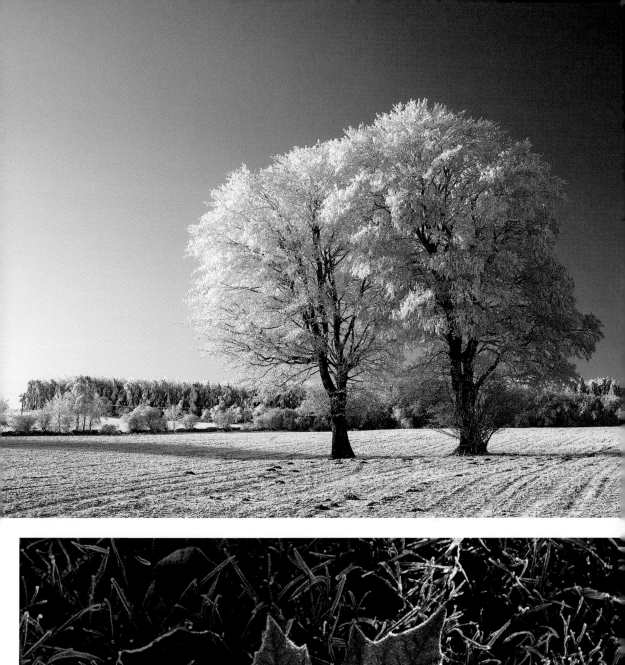
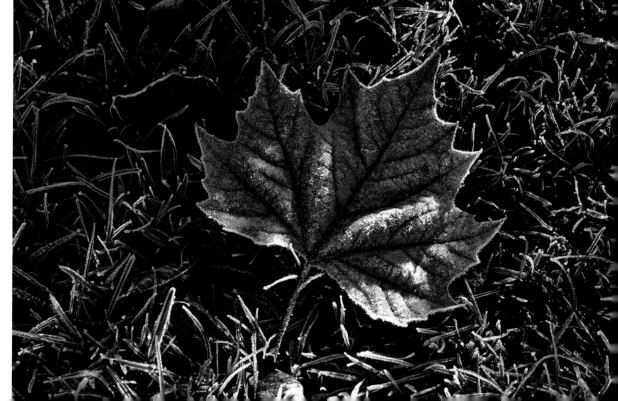

A Rough Night

below—It was a bit of a rough night I spent here. I slept in the car, which was very cold indeed—but I was rewarded with a spectacular misty dawn, which made these trees (in The Wye Valley of Wales) look wonderful.

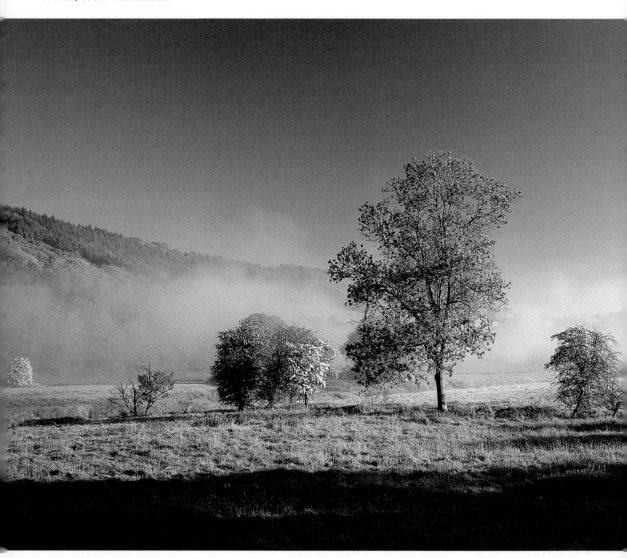

Always Looking

below—I remember where outstanding trees are and make sure to take a look whenever I'm traveling past. I was on my way back from photographing a beach on the south coast of England when I saw this oak tree with a beautiful setting sun behind it.

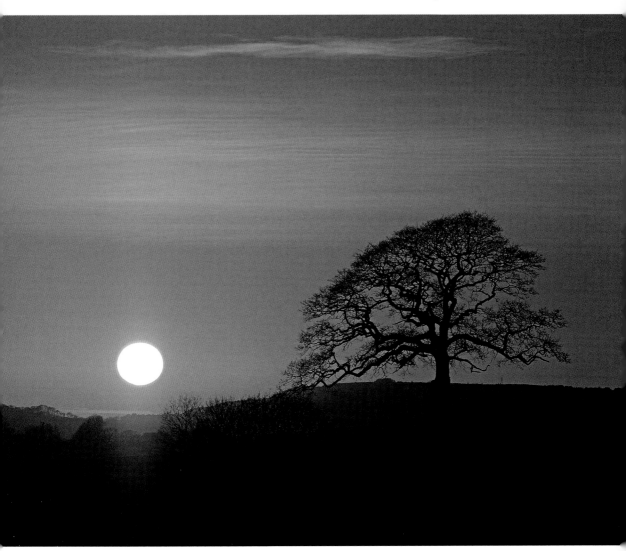

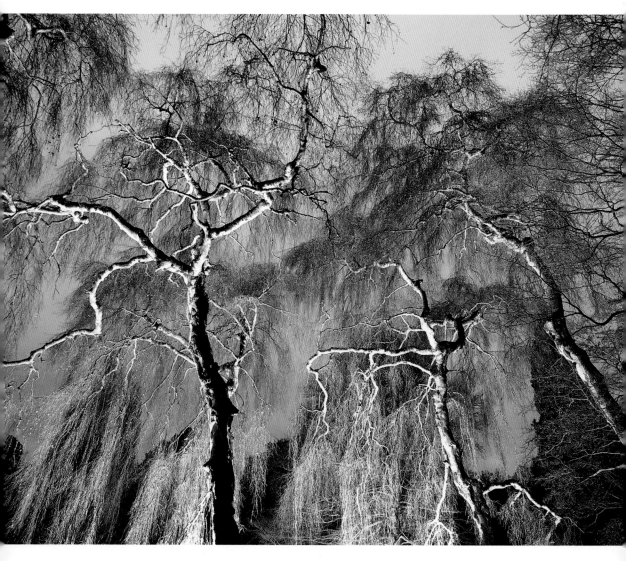

Weeping Birch at Dusk

above—This group of weeping birch (Betula pendula 'Youngii') trees
took on a slightly spooky appearance when illuminated at dusk.
But, given that dusk is around 4PM in England during deep winter,
I wasn't scared!

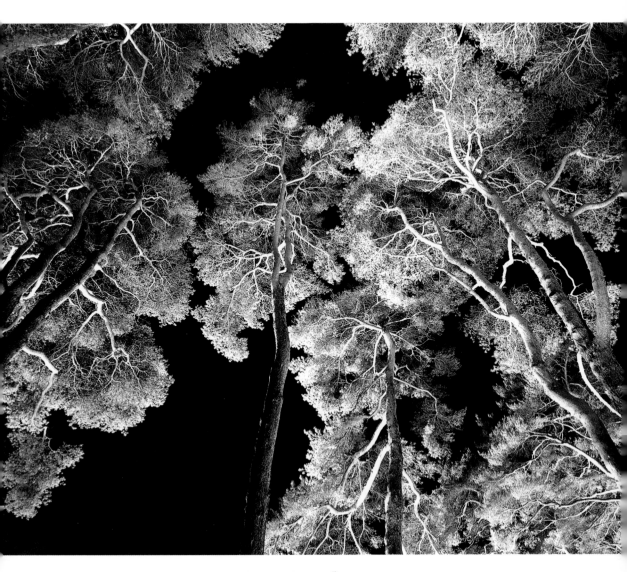

Scots Pines at Night

above—This group of Scots pine trees (Pinus sylvestris) is looking very dramatic and fractal. They were illuminated and photographed after dark at wonderful Westonbirt, the National Arboretum of England. This is a place I frequent because it has 18,000 trees from all over the world.

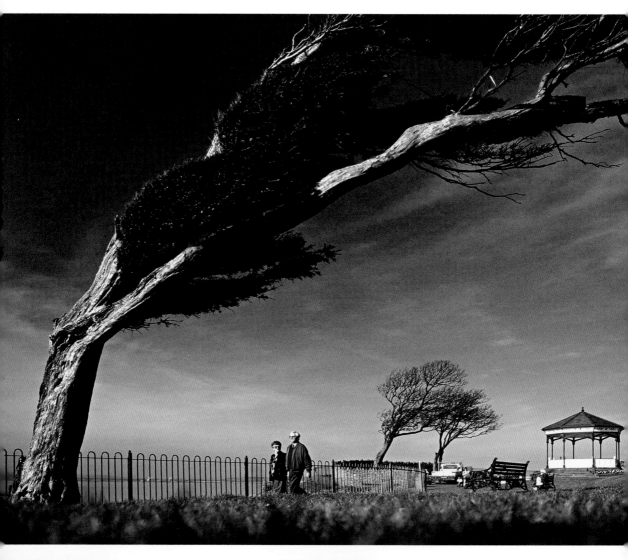

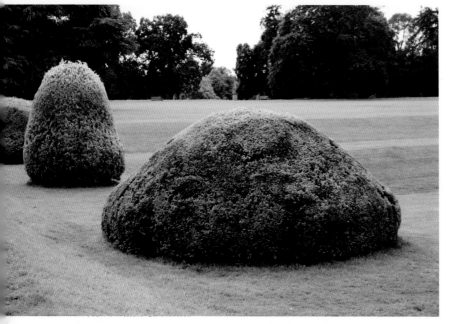

Yew

above—This old yew tree is growing on the seashore in Clevedon, England. It gets a real battering from the predominant Atlantic winds—hence, its dramatic lean!

left—Here, yew is seen clipped into different shapes at Forde Abbey, England.

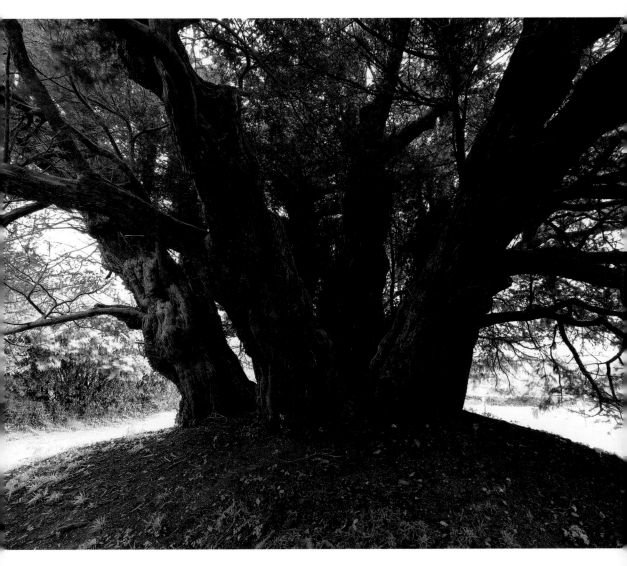

Ancient History

above—Reputedly the oldest living thing in England, this yew tree is over 3,000 years old. It was mature when Stonehenge was in use—1,000 years before Jesus Christ. It's quite something to see a tree that old. I've seen them in the United States (they have even older trees there; the bristlecombe pine is 5,000 years old!) but didn't know we had any that old until I discovered this one. It was planted on a barrow (tomb) so it probably has someone important buried underneath. The famous English poet William Wordsworth came to see it and wrote some prose. It looks good enough for at least another thousand years.

below—The twisted base of a yew tree.

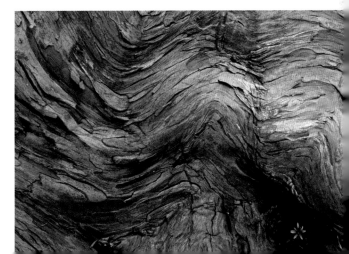

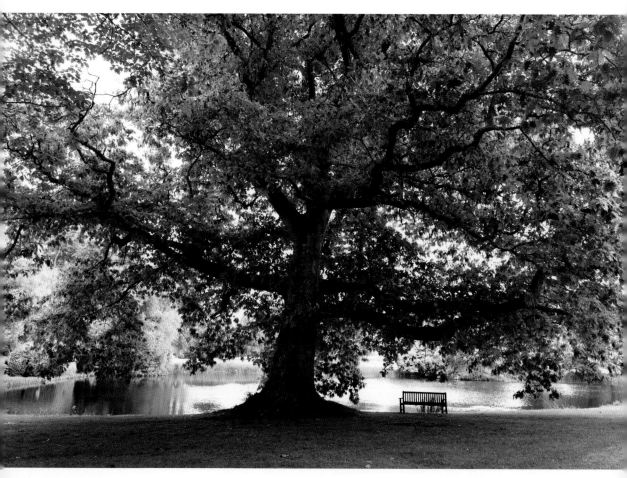

Red Oak

above—In the United States, the red oak (Quercus rubra) is the provincial tree of Prince Edward Island, as well as the state tree of New Jersey. This beautiful specimen is growing by the side of a lake in Forde Abbey, England.

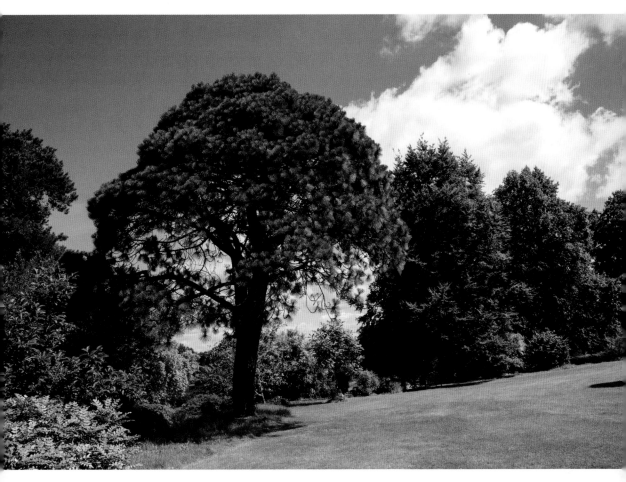

Montezuma Pine

above—The Montezuma pine (Pinus montezumae) is native to
Mexico and the central United States. Its resin is very flammable,
hence the wood is often used as a fire starter for campfires and
barbecues.

Index

Bushwhacking: Your Way to Great Landscape Photography

Spencer Morrissey presents his favorite images and the back-country techniques used to get them. *$37.95 list, 7x10, 128p, 180 color images, index, order no. 2111.*

Storm Chaser
A VISUAL TOUR OF SEVERE WEATHER

Photographer David Mayhew takes you on a breathtaking, up-close tour of extreme weather events. *$24.95 list, 7x10, 128p, 180 color images, index, order no. 2160.*

Underwater Photography

Take an underwater journey with Larry Gates as he explores a hidden world and reveals the secrets behind some of his favorite photographs created there. *$37.95 list, 7x10, 128p, 220 color images, index, order no. 2116.*

Create Fine Art Photography from Historic Places and Rusty Things

Tom and Lisa Cuchara take photo exploration to the next level! *$19.95 list, 7x10, 128p, 180 color images, index, order no. 2159.*

Bonnet House EXPLORING NATURE AND ESTATE PHOTOGRAPHY

Photograph the grounds of a historic Florida estate—and the plants and animals that make their home there. *$24.95 list, 7x10, 128p, 180 color images, index, order no. 2153.*

iPhone Photography for Everybody

Accomplished photojournalist Michael Fagans shows you how to create awesome photos with your iPhone. *$19.95 list, 7x10, 128p, 180 color images, index, order no. 2157.*

Rocky Mountain High Peaks

Explore the incredible beauty of America's great range with Brian Tedesco and a team of top nature photographers. *$24.95 list, 7x10, 128p, 180 color images, index, order no. 2154.*

Hubble Images from Space

The Hubble Space Telescope launched in 1990 and has recorded some of the most detailed images of space ever captured. *$24.95 list, 7x10, 128p, 180 color images, index, order no. 2162.*

Rescue Dogs
PORTRAITS AND STORIES

Susannah Maynard shares heartwarming stories of pups who have found their forever homes. *$21.95 list, 7x10, 128p, 180 color images, index, order no. 2161.*

Art with an iPhone, 2nd ed.

Kat Sloma's elegant images reveal the iPhone as a sophisticated art-making tool. In this book, she walks you through her inventive approach. *$24.95 list, 7x10, 128p, 300 color images, index, order no. 2165.*

Inside Aviation Photography

Take wing with Chad Slattery as he photographs from the air and ground, shooting planes, pilots, and more. *$24.95 list, 7x10, 128p, 180 color images, index, order no. 2167.*

Dogs 500 POOCH PORTRAITS TO BRIGHTEN YOUR DAY

Lighten your mood and boost your optimism with these sweet and silly images of beautiful dogs and adorable puppies. *$19.95 list, 7x10, 128p, 500 color images, index, order no. 2177.*

Top Dogs
PORTRAITS AND STORIES

Diane Costello shares stories about our constant companions and highlights the roles they play in our lives. *$24.95 list, 7x10, 128p, 180 color images, index, order no. 2169.*

Owls in the Wild
A VISUAL ESSAY

Rob Palmer shares some of his favorite owl images, complete with interesting stories about these birds. *$24.95 list, 7x10, 128p, 180 color images, index, order no. 2178.*

Big Cats in the Wild

Joe McDonald's book teaches you everything you want to know about the habits and habitats of the world's most powerful and majestic big cats. *$24.95 list, 7x10, 128p, 220 color images, index, order no. 2172.*

Polar Bears in the Wild
A VISUAL ESSAY OF AN ENDANGERED SPECIES

Joe and Mary Ann McDonald's polar bear images and Joe's stories of the bears' survival will educate and inspire. *$24.95 list, 7x10, 128p, 180 color images, index, order no. 2179.*

Bald Eagles in the Wild
A VISUAL ESSAY OF AMERICA'S NATIONAL BIRD

Jeff Rich presents stunning images of America's national bird and teaches readers about its daily existence and habitat. *$24.95 list, 7x10, 128p, 250 color images, index, order no. 2175.*

Wicked Weather
A VISUAL ESSAY OF EXTREME STORMS

Warren Faidley's incredible images depict nature's fury, and his stories detail the weather patterns on each shoot. *$24.95 list, 7x10, 128p, 190 color images, index, order no. 2184.*

Horses
PORTRAITS & STORIES

Shelley S. Paulson shares her love and knowledge of horses in this beautifully illustrated book. *$24.95 list, 7x10, 128p, 220 color images, index, order no. 2176.*

The Frog Whisperer
PORTRAITS AND STORIES

Tom and Lisa Cuchara's book features fun and captivating frog portraits that will delight amphibian lovers. *$24.95 list, 7x10, 128p, 500 color images, index, order no. 2185.*